The
Art
and
Flair
of

Mary Blair

AN APPRECIATION

By

JOHN CANEMAKER

EDITIONS

NEW YORK

OTHER BOOKS BY JOHN CANEMAKER:

The Animated Raggedy Ann & Andy (1977)

Winsor McCay: His Life and Art (1987)

Felix: The Twisted Tale of the World's Most Famous Cat (1991)

Tex Avery: The MGM Years (1997)

Before the Animation Begins: The Art and Lives of Disney Inspirational Sketch Artists (1997)

Paper Dreams: The Art and Artists of Disney Storyboards (1999)

Walt Disney's Nine Old Men & the Art of Animation (2001)

Two Guys Named Joe: Master Animation Storytellers Joe Grant and Joe Ranft (2009)

By John Canemaker and Robert E. Abrams: *Treasures of Disney Animation Art* (1982)

By John Canemaker and Joseph Kennedy: *Lucy Goes to the Country* (1998)

Copyright © 2003, 2014 Disney Enterprises, Inc. All rights reserved. Published by Disney Editions, an imprint of Disney Book Group. No part of this book may be reproduced or transmitted in any form or by any means, electronic or mechanical, including photocopying, recording, or by any information storage and retrieval system, without written permission from the publisher. For information address Disney Editions, 1101 Flower Street, Glendale, California 91201.

It's A Small World artwork is from the Walt Disney Imagineering Archives.

All other artwork not attributed to individual collectors is from the Walt Disney Animation Research Library.

Audio-Animatronics® is a registered trademark of The Walt Disney Company.

Oscar® and Academy Award® are registered trademarks of the Academy of Motion Picture Arts and Sciences.

Emmy® is a registered trademark of the Academy of Television Arts and Sciences.

ISBN 978-1-4231-2744-4
F850-6835-5-14003
Printed in Singapore
Updated Edition
10 9 8 7 6 5 4 3 2 1

Library of Congress Cataloging-in-Publication Data
Canemaker, John.
The art and flair of Mary Blair : an appreciation / by John Canemaker.—Updated edition.
pages cm
Summary: "For more than a dozen years, a soft spoken, unassuming woman dominated design at The Walt Disney Studios with a joyful creativity and exuberant color palette that stamped the look of many classic Disney animated features, including Cinderella and Peter Pan. Favorite theme park attractions, most notably the "It's A Small World" boat ride, originally created for the 1964 New York World's Fair, were also among her designs. Now the story behind one of Walt's favorite artists is celebrated in this delightful volume of whimsical art and insightful commentary. In her prime, Mary Blair was an amazingly prolific American artist who enlivened and influenced the not-so-small worlds of film, print, theme parks, architectural decor, and advertising. Her art represented and communicated pure pleasure to the viewer. Mary Blair's personal flair was at one with the imagery that flowed effortlessly and continually from her brush for more than half a century. Walt Disney loved her art and championed it at the Studio. The two shared many sensibilities, including a childlike fondness for playfulness in imagery."
—Provided by publisher.
ISBN 978-1-4231-2744-4 (hardback)
1. Blair, Mary, 1911-1978. 2. Animators—United States—Biography. 3. Women animators—United States—Biography. 4. Walt Disney Productions—History.
I. Title.
NC1766.U52B5733 2014
709.2--dc23
[B]
2013028923

Visit www.disneybooks.com
Visit www.johncanemaker.com

CONTENTS

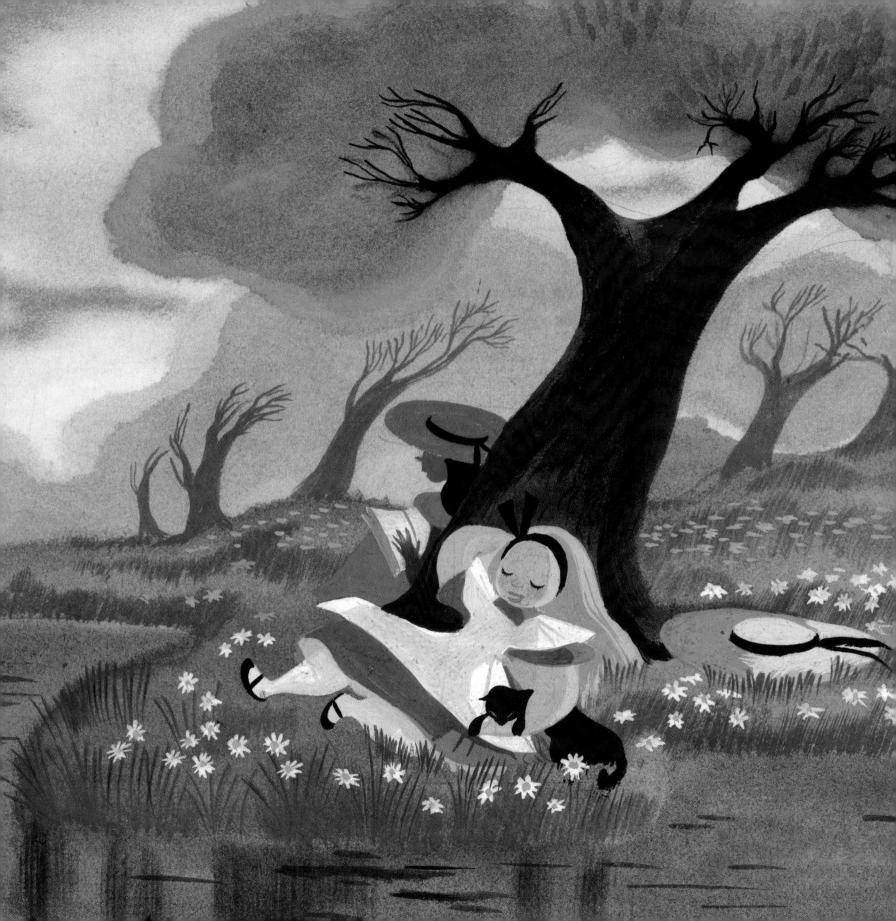

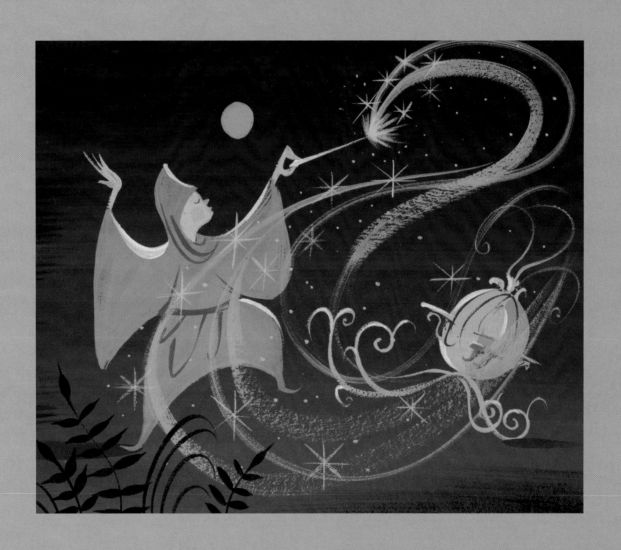

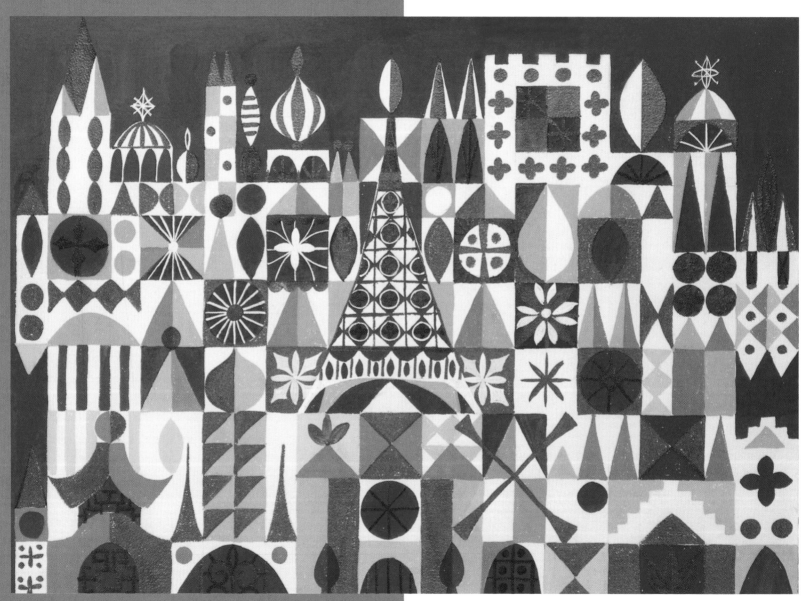

Mary Blair conceptual collage for It's A Small World, 1964.

Introduction

Mary's World

The 1964 New York World's Fair arrived a few months after President John F. Kennedy's assassination and a year before America became fully embroiled in Vietnam. It was a last grand utopian dream of international unity and peace, and a paean to progress through corporate technology.

Among the fair's sponsors were General Electric, Ford, Pepsi-Cola, and the State of Illinois, each of which commissioned large exhibitions from Walt Disney and the artist-technicians he called his "Imagineers." After months of design and construction in Glendale, California, the exhibits were shipped to the fairgrounds in Queens, New York.

Installation proceeded apace, but the fair's opening on April 22, 1964, proved to be less than a Zip-a-Dee-Doo-Dah day.

Although President Lyndon Johnson was the keynote speaker, attendance at the huge exposition was sparse due to cold, rainy weather. There was also a "stall-in" by civil rights demonstrators from the Congress of Racial Equality.[1]

Time magazine dubbed Walt Disney "the fair's presiding genius," but on opening day, three of his four exhibitions experienced technical problems.[2] The worst was the Illinois exhibit, which featured a speech by an Audio-Animatronics Abraham Lincoln. Power surges gave robotic Honest Abe fits so violently unpresidential, Disney temporarily closed the show.[3]

It's A Small World, a comparatively simple Pepsi-Cola–sponsored attraction for the United Nation's Children's Fund (UNICEF), enjoyed a smoother premiere. In fact, the charming dramatization of the theme, "every child is all children," became one of the fair's most memorable exhibits.[4]

In It's A Small World, boats holding fifteen passengers floated through twenty-six "countries" populated by 250 Audio-Animatronics "toys." The colorful, stylized settings included onion-shaped Russian domes, Turkish mosques, Japanese arches, a Brazilian carnival, and African grass huts, among other locales; within them diminutive roundheaded dolls dressed in native costumes sang and danced, along with assorted country-appropriate animals such as Belgian geese, an Asian tiger, an Indian cobra, and Chilean penguins.

The puppet's choreography was synchronized to a simple, repetitious ditty ("It's a small world after all"); dubbed into twenty-six languages, it stuck in the mind like musical glue.[5]

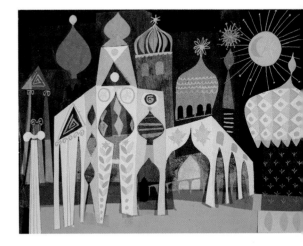

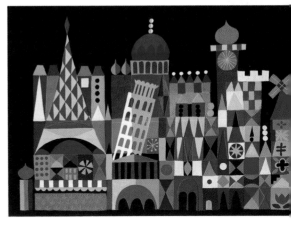

Above and below: Blair conceptual art for It's A Small World.

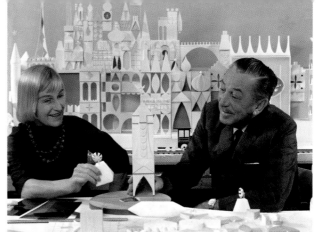

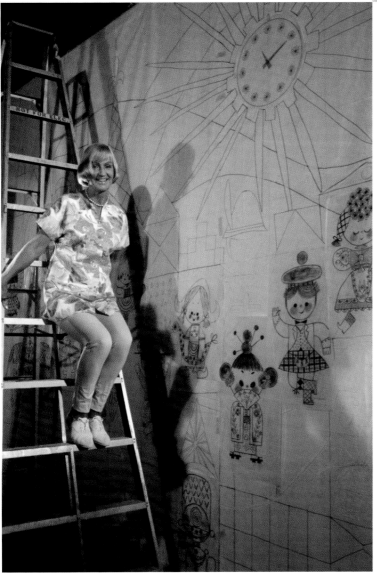

Right: Mary Blair and Walt Disney collaborating on It's A Small World in 1964.
Below: Mary Blair planning the UCLA/Stein Eye Institute mural grid, 1966.

On a sheltered VIP observation deck above the exhibit, replete with snacks, Pepsi-Cola, and martinis, key Pepsi and Disney personnel and their families celebrated the team who had put together It's A Small World from scratch in a mere nine months. Participating with quiet pride alongside her husband, Lee, and teenage sons, Donovan and Kevin, was the artist responsible for the overall design and color styling of It's A Small World: Mary Blair.

Despite overcast skies, the fifty-two-year-old artist wore dark glasses to protect her sensitive green eyes. An ash-blond pageboy hairdo framed the elegant profile of her long face and aquiline nose. She smoked Parliaments, using a white cigarette holder that matched the striking ensemble she herself had designed: a white skirt and jacket with cape, perfectly accented by a black turtleneck sweater. Blair always considered white the most "festive" of colors, and made it the dominant hue in It's A Small World's finale.[6]

"This is the most interesting job I've ever had," she later said. "[T]he results are more delightful than anything I've tried before."[7]

The exhibition was, in fact, a three-dimensional culmination of the brilliant art Mary Blair created by the dozens for Disney films. For more than a decade, this unassuming, quiet-spoken woman dominated Disney design.

The stylishness and vibrant color of Disney films in the early 1940s through mid-1950s came primarily from Mary Blair. In her assignments for Disney and other companies, her unique style and distinctive artistic vision pervade every film, children's book, advertisement, set design, and large-scale mural.

She was born Mary Browne Robinson on October 21, 1911, in McAlester, Oklahoma. The family was poor, the father amiably alcoholic

and peripatetic. By age seven, Mary, her parents, and two sisters, including her fraternal twin, had settled in Morgan Hill near San Jose, California.

Her artistic gift manifested itself early. At twenty she won a scholarship to the Chouinard School of Art in Los Angeles. There she aspired to become an illustrator like her favorite teacher, Pruett Carter (1891–1955).

Her marriage in 1934 to another scholarship student, Lee Blair (1911–1993), led to an interest in fine-art painting. During the Depression, the Blairs became important participants in the regionalist California school of watercolorists. The couple exhibited in galleries nationwide, but reluctantly supported themselves working at several Hollywood cartoon studios.

At Disney's, Mary Blair first gained attention with exciting conceptual paintings for the South American features *Saludos Amigos* (1943) and *The Three Caballeros* (1945); she suggested color and styling for postwar omnibus (or "package") features *Make Mine Music* (1946), *Melody Time* (1948), and *The Adventures of Ichabod and Mr. Toad* (1949); designed sets and costumes for the combination animation-with-live-action films *Song of the South* (1946) and *So Dear to My Heart* (1949); and created color concepts for the full-length animated fairy tales *Cinderella* (1950), *Alice in Wonderland* (1951), and *Peter Pan* (1953), plus the 1952 shorts *Susie the Little Blue Coupe* and *The Little House*.

Small gouache-and-watercolor paintings flowed from Blair's brush suggesting possibilities for staging actions; the mood and emotional content of scenes; and color and design ideas for characters, props, costumes, and backgrounds. She described her job as "working with the writers and helping to create the ideas of the picture graphically right from . . . its basic beginning."[8] Her inventiveness proved a constant inspiration to story, background, layout, and animation crews.

Walt Disney loved her art and championed it at the studio. This struck some as odd, for Blair's stylization is the polar opposite of the representational "illusion of life" associated with Disney animated films. Her work is flat, antirealist, and childlike (faux naïf), painted with a wildly unrealistic color palette.

Mary Blair in South America, 1941.

Her work evokes the soft abstraction of Milton Avery and Marguerite Zorach rather than the homely representational style of Norman Rockwell and Gustaf Tenggren, who also influenced Disney design. She is more interested in playing with color and form than developing personalities. Her figures tend to be small and to float surrealistically, as part of the overall textures, interlocking shapes, and patterns in nearly abstract compositional structures.

To Disney, this was a form of modernism that he was comfortable with; but others at the studio resisted. "Walt told us he wanted us to get Mary Blair's stuff on the screen," cried an animator, "but it was impossible. Her stuff is very flat!"[9] Others, in that male-dominated beehive that was the Disney studio in those prefeminist days, jealously questioned why so much creative power was given to a woman.

Disney's interest in Mary Blair's art is intriguing, notes art historian Karal Ann Marling, precisely because it "contradicts so much that we seem to know about Walt Disney."[10] Indeed, people tend to forget how avidly Disney explored new ideas throughout his career.

He was responsive to technical innovations, such as the three-color Technicolor process, stereophonic sound, and television, as well as varied artistic influences: European children's book illustrations, Norman Rockwell, Thomas Hart Benton, Rockwell Kent, German Expressionist cinema, Len Lye and Oskar Fischinger's animated abstractions, and Salvador Dali's surrealism, among others. As one artist put it, Disney "was constantly growing, constantly reaching out. He always wanted to see things he never saw before."[11] If it might enhance his projects, any artistic style was fair game for exploration and adaptation.

Blair showed him color and forms that constantly surprised and delighted him. They shared many sensibilities, including a childlike fondness for playfulness in imagery, alongside a seriousness of purpose even with playful things. Both were unafraid of hard work, and Disney appreciated Blair's diligence in turning out many variations on a subject in order to give him choices. She was a prolific but inspired painting machine.

Disney admired her professionalism, the craftsmanship beneath her deceptively simple faux-folk style. The simplicity may resemble Grandma Moses or Doris Lee, but Mary Blair had enormous sophistication beyond regionalist art in everything from color choices to composition.

Blair's concept art for "Las Posadas," a Mexican Christmas story in The Three Caballeros *(1945).*

Walt responded to the storytelling aspect of her pictures—especially the underlying emotion palpable in much of her art, even when veering toward abstraction. Deeply sensitive, Blair identified with the characters and situations she painted—be it little Alice lonely and lost in wild Wonderland; or Cinderella dreamily contemplating a better tomorrow from her garret window; or the colorful abandon of zany Brazilian parrots frolicking on piano keys in a place beyond our everyday world. Many paintings are self-portraits of her inner feelings.

Disney and Blair shared a love of family and children. Blair's creative expression was enriched by the notion of motherhood, togetherness, family, love, and babies. One of her signature designs is the "Mary Blair child," a Keane-eyed urchin with a hydrocephalus head atop a tiny body, who appears in several projects, from the "Las Posadas" sequence of *The Three Caballeros* to the It's A Small World dolls. The "Blair kid" also appeared in 1950s advertisements and fondly remembered Golden Press children's books.

Through the years, Disney's creations, writes historian Steven Watts, "helped Americans come to terms with the unsettling transformations of the twentieth century."[12] Inadvertently, Mary Blair's art helped Disney "not only as an entertainer but as a social mediator."[13]

Blair and Disney were both unconsciously in tune with America's evolving culture. Often, she was ahead of the curve. During World War II and the restructuring of society that came after, the Mary Blair child represented a lament about American innocence lost and family values, while simultaneously reaffirming those values.

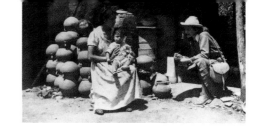

When Franklin Delano Roosevelt's Good Neighbor policy toward South America prepped the country for war, Blair's paintings, ablaze with color and made on-site in mid-1941 in Rio de Janeiro, Buenos Aires, Lima, and other South American locales, fit the bill. She changed practically overnight from a generic regionalist painter to a distinctive artist at once bolder and more modern.

Disney saw it happen before his eyes and instinctively understood that Blair's assertive art was in sync with the changing times and future projects. The delicate Arthur Rackham–like fairy-tale illustrations that inspired *Snow White and the Seven Dwarfs* (1937) were out; bold graphics, stylization, and surrealism were in, as exemplified in the phantasmagoria of *The Three Caballeros*.

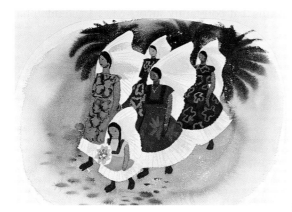

Above: Mary Blair sketching in Peru, 1941.

Right: Larry Lansburgh, Mary Blair, and Fred Moore at The Three Caballeros *party, 1945.*

Above: South American women painted on location, 1941.

Right: Fanciful Mexican birds ride burros in concepts for The Three Caballeros.

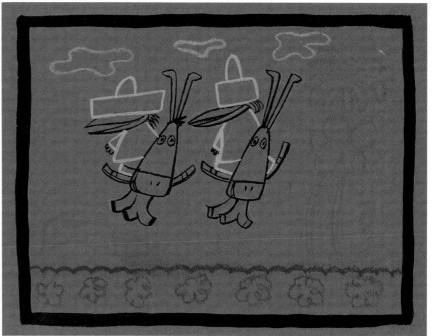

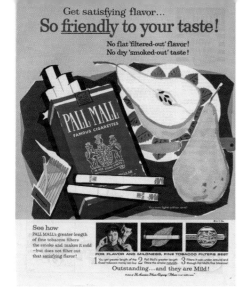

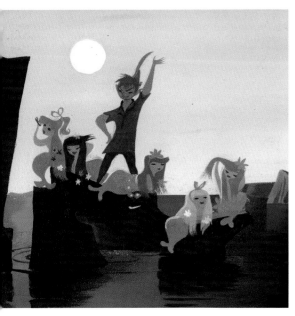

Top: Pall Mall advertisement design, c. 1950s.

Above: Peter and mermaids in a color/styling suggestion for Peter Pan *(1953).*

Blair's work also anticipates the "softer forms and undulating lines with organic or biological sources [that] defined the most innovative and 'modern' art forms of the postwar period."[14] Where did her bull's-eye stylishness come from?

Professor Marling contends that it was "sucked out of the culture. Mary Blair was a very sensitive seismograph, who was not part of the historical nonsense regarding formal modern art influences."[15] Undoubtedly, she was exposed to modern art through her teachers at Chouinard and the gallery scene in Los Angeles. She also saw a wide variety of art when she lived on the East Coast from 1946 through 1970.

But her greatest influences came from contemporary sources everywhere. She absorbed elements of the visual environment wherever she was and reflected them back in her own painting: the folk art and colors of South America; European art posters and advertisements; fashion illustrations in *Vogue* and *Harper's Bazaar*; Zeisel kitchen pottery; Eames chairs; Noguchi tables; Christian Dior dresses; *New Yorker* covers; the organic shapes, vital forms, and odd colors of abstracted nature in Army camouflage; American quilts; Formica boomerang patterns; the pastel palettes of Kelvinator appliances; molded Tupperware plastic; the experimental murals of David Alfaro Siquerios (who taught at Chouinard); the interior design of the Lapidus stores and hotels; the madly colored and concisely designed caricatures of Paolo Garretto and Miguel Covarrubias in *Vanity Fair*.

Joe Grant, who joined the Disney studio in 1933, previously drew caricatures for the *Los Angeles Record*; seven years later, Blair worked under Grant's supervision in Disney's Character Model department.[16]

The graphic wit of caricatures, writes Wendy Wick Reaves, "expressed a diluted form of modern art, derived not only from the artistic avant-garde but from contemporary graphic design, fashion, theater, and the popular arts." Like advertising art, caricatures "borrowed from contemporary aesthetic trends to convey dynamic energy and sophistication" and "evoked the fashionable modernity of urban life."[17] "Mary absorbed all those things," concurs animation art director Michael Giaimo, "because they were all over the place."[18]

In her personal life, Blair anticipated the modern professional woman and homemaker. "I had three jobs," she said in 1971: "raising children, keeping house, and doing my artwork."[19] She was a "high-achieving woman" who postponed starting a family until she was thirty-six.

Even after the birth of her second child three and a half years later, Mrs. Blair continued to juggle family life and career. Starting in the mid-1940s, she worked at home in Long Island and traveled to California for meetings at the Disney studio, a "frequent flyer" years before there was such a thing. Her "have it all" lifestyle was not the norm for most American women in the 1940s and 1950s.[20]

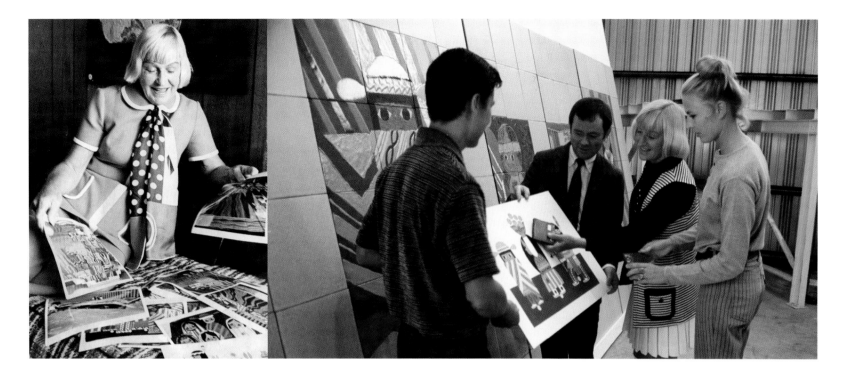

Blair left the Disney organization in 1953 to freelance in advertising and children's book illustrations. A decade later, Walt Disney personally asked her to design It's A Small World. Happy to be working again with her old boss and delighted with the project, Blair rapidly poured forth inspired visualizations.

She continued as a design consultant on large-scale ceramic-tile projects that Disney himself set in motion before he died in 1966. During her last years, family and personal problems exacerbated by alcohol abuse, led to a deterioration of Mary Blair's physical and mental health and, subsequently, her art. She died in 1978 in Soquel, California, at sixty-seven.

In her prime, she was an amazingly prolific American artist who enlivened and influenced the not-so-small worlds of film, print, theme parks, architectural decor, and advertising. At its core, her art represents joyful creativity and communicates pure pleasure to the viewer. Her exuberant fantasies brim with beauty, charm, and wit, melding a child's fresh eye with adult experience. Blair's personal flair was one with the imagery that flowed effortlessly and continually for more than half a century from her brush.

Emulated by many, she remains inimitable: a dazzling sorceress of design and color.

A small portion of all things Mary Blair lies before you in the present volume.

Above left and right: Mary Blair at work on Walt Disney World's Contemporary Resort, 1971.
Below: Mary Blair at work in her studio.

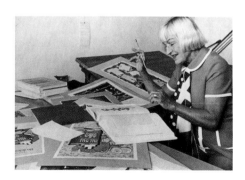

Chapter One

Watercolor Years

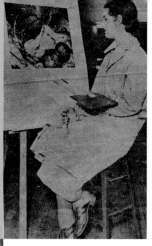

Let us begin with a contemplative self-portrait of Mary Robinson Blair, a charming watercolor made soon after she married Lee Blair in 1934, when both were in their early twenties.

The delicate, naturalistic study little indicates the lyrical fancy, saturated hues, and stylized flatness to come. Yet, the wallpaper patterning, bedspread, and robe anticipate her mature work's calligraphic freedom.

The controlled washes show that she already can summon forth light from shadow effectively and define forms in a painterly, rather than graphic, way. Color surprises include the yellow dress beneath a white robe, and red paint streaming from a brush in a water jar. One notices Blair's innate story-telling powers: a garment carelessly thrown atop a bureau, a single shoe on the floor, the unmade bed indicate that mundane house-keeping is ignored when the intense sitter focuses on making art. Mary Robinson Blair

Above: Mary Robinson at San Jose State College, c. 1930.

Left: A watercolor self-portrait of the artist, c. 1934. Collection of Kevin Blair.

An early 1930s Mary Blair watercolor influenced by illustrator Pruett Carter. Collection of Fred Cline.

WINNING DESIGN GAINS GIRL FAME

Miss Mary Robinson

was "single-minded when it came to her talent or drive," remembers niece Maggie Richardson.[1] Although mild-mannered and self-possessed, "she had a strong desire to do her painting from childhood on," concurs another niece, Jeanne Chamberlain.[2] Money was tight, but young Mary requested a portion of the family budget for art supplies. "Dad will just drink it up anyway," she reasoned matter-of-factly.

The evocative composition of her self-portrait reflects Pruett Carter's tutelage. Of all her teachers at Chouinard, Blair claimed he was the "greatest influence."[3] A renowned, well-paid illustrator for *Ladies' Home Journal* and *McCall's*, and former *Good Housekeeping* art director, Carter was, recalls It's A Small World costumer Alice Davis, "at one time the number one magazine illustrator in New York. The best!"[4]

His classes were "very tough," says Mrs. Davis. "You couldn't do anything without permission. He didn't give his students [coffee] breaks. Sometimes you'd miss your whole lunch." Carter reinforced Mary's work ethic and taught her "a great deal in regards to staging and composition."

His specialty was visualizing key, dramatic, emotion-laden moments: the telling scene. In 1948, Carter wrote:

> *The illustrator's first function is a problem of composition, of pattern, of design—including the rich contrast of the illustration itself with the type matter and headlines of the story. Actually, the illustrator may be likened to the director of a motion picture. . . . He must live the part of each actor. He must do the scenery; design the costumes; and handle the lighting effects.[5]*

For classroom assignments, Carter chose stories from an earlier era, necessitating research into period fashions. Live models aided figure placement, expressions, and gestures. Blair proved a stellar student. Three early watercolors of characters in nineteenth-century garb convincingly depict scenes of romance, confrontation, and revelation.

A further indication that she was destined for a career in the applied arts came in April 1932 when she won first prize—a much-needed $100—in a nationwide competition. Her Art Deco Trojan horse design was chosen for Cannon towels, mats, and facecloths. The elegant emblem in blue, jade, and maize anticipates the stylization and color sense that became Mary Blair's future signature.

"My first ambition and art school–formed aspiration," she wrote years later, "[was] illustration." However, her artistic skills and goals were expanded in a noncommercial, art-for-art's-sake direction through the influence of her new husband.

Lee Blair was a serious young artist focused on the fine arts. In the summer of 1932, he assisted experimental muralist David Alfaro Siqueiros on a Chouinard project. More important, that year he won a first-place gold medal in the International Art Competition of the Olympic Games.[7] By age twenty-three, he was elected president of the California Watercolor Society.

Newlyweds Lee and Mary Blair idealistically dedicated themselves to a life together as fine artists, and Lee arranged exhibits of their work throughout the 1930s. (Mary was one of only four Californians included in the important 1936 Texas Centennial exposition.) The two became key participants in "the only important regional school of watercolor within the context of the American scene movement," writes Susan M. Anderson.[8]

The California School style used "a large format, free broad brushstrokes, and strong, rich colors," according to Gordon T. McClellend. Scenes and activities of everyday life on the Pacific coast were painted "boldly and directly, with little or no preliminary pencil sketching, while mastering the technique of allowing the white paper to show through as an additional shape or color."[9]

"We are artists, dear, and in love with art and each other," Mary wrote to Lee in an undated note circa 1934.

> *We must make these loves coincide and melt into a beautiful, happy & rich life. That is our future and is real. We'll live to be happy and paint to express our happiness.*

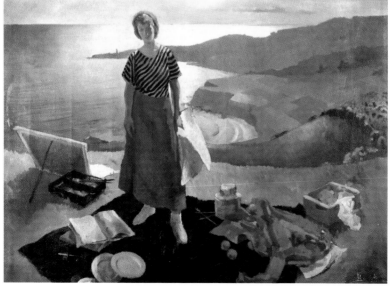

Top: Lee Blair, c. 1934; he and Mary met as scholarship students at L.A.'s Chouinard School of Art.

Above: Lee and Mary wed on March 3, 1934.

Left: "Mary by the Sea," a large oil, c. 1934, by Lee Blair. Collection of Kevin Blair.

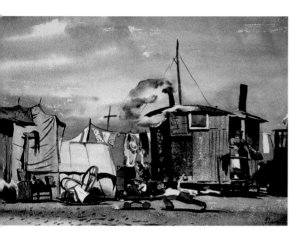

"Oakie Camp," a 1933 Mary Blair watercolor, focuses on everyday human qualities in the plight of Dust Bowl escapees.

A six-week 1938 painting tour of Mexico led to a one-woman show at Los Angeles's Tone Price Gallery. The *Los Angeles Times* reviewer noted that Mary's watercolors were as "lively as those of her husband" and "much like them in subject and technique," although "her reactions to nature" were "more sensual than his."[10] Pictures from this show, such as *End of the Day*, *Laundry Day*, *The Circus*, and *Chicken Coops*, feature lush, broad washes, contrasted with areas filled with calligraphic storytelling details. Figures are invariably tiny, dwarfed among looming, dramatic, dominant abstract shapes.

Humanism and gentle humor are often present in Blair's work. Oakie Camp focuses on everyday life among the displaced who fled west to escape the Dust Bowl: kids play, Pa hangs laundry, Ma empties a bedpan. The artist "makes no direct social commentary," writes Susan M. Anderson. "Instead of approaching her subject matter with sobriety, [she] ironically invoked an animated orchestra of shape and color to describe the camp with touching humanity."[11]

The *Western Woman* magazine of spring 1938 described "Mary Robinson Blair" as "one of the younger Los Angeles artists who is gaining recognition for the sincerity and originality of her work." The article, "Practical Values of Art," praised her appreciation of "the commercial value of art" by "turning her talent as a designer to practical uses."[12]

In fact, soon after marrying, both Blairs took "practical" low-level jobs at Ub Iwerks's animation studio: Lee was an assistant animator (an "in-betweener"), and Mary painted characters on cels.

"We both had shows and painted like hell [on] weekends and [were] selling our paintings, but you can't live that way," Lee recalled half a century later.[13] Fiscal reality during the Depression compromised their dream of supporting themselves as fine artists. Animation, Lee claimed, was "way beneath our standards, but we needed to eat."[14] Mary described their conflicted artistic life as "a Jekyll-Hyde existence."[15]

When Lee moved on to a better-paying position at the Harman-Ising studio as a "color director," Mary stayed home to paint. In May 1938, Lee left Harman-Ising for Disney where he worked as a color director on *Pinocchio* and *Fantasia*.

Mary recalled: "There was no one then in the business to take his place [at Harman-Ising]. I was called to give it a try." Lee ruefully remembered, "They said, 'Why don't we hire his wife? She's better than he is!' "[16]

Mary was "called out of a domestic life," as she puts it, "I was studying illustration, life, and easel painting on the side. My ambition had certainly not been directed toward the animation cartoon field. I didn't want the job. Three and a half years [sic] in the business with [Rudolf] Ising still didn't convince me."[17]

Then, in April 1940, "with the necessary push from Lee," she recalled, "I reluctantly moved to sketch for Disney."[18]

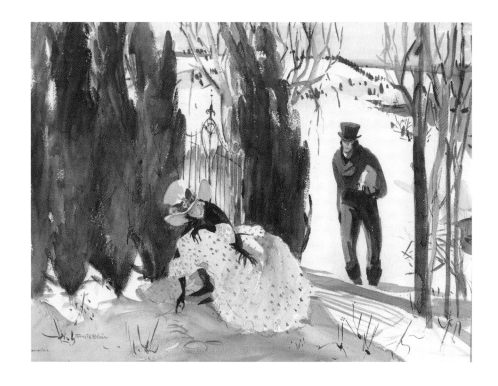

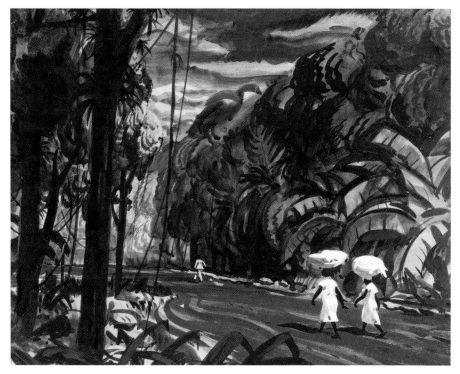

Top: A romantic study made for Pruett Carter's illustration class at Chouinard, c. 1932. Collection of Fred Cline.

Left: "The Island," an example of Lee Blair's watercolor skills, c. 1938. Courtesy The Michael Johnson Collection.

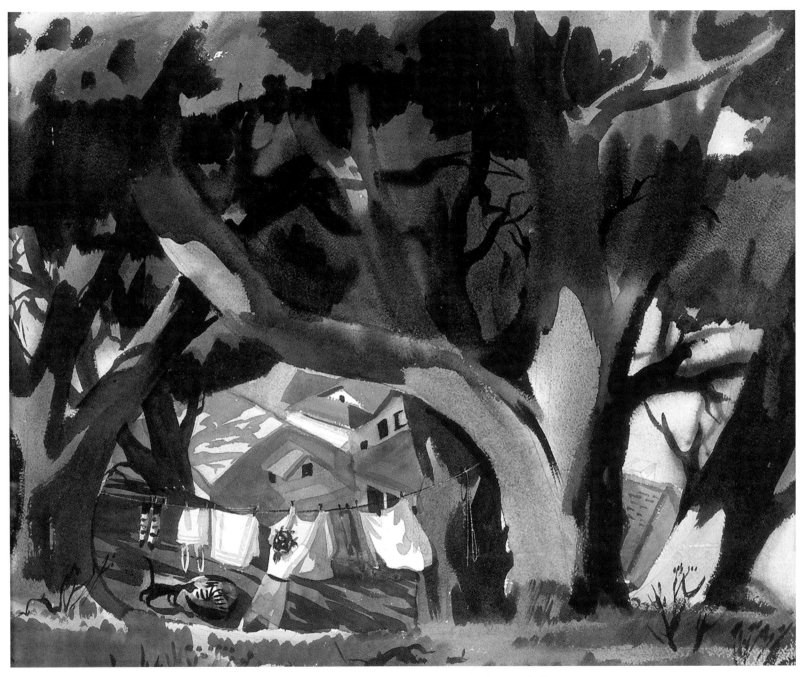

"Laundry Day," watercolor by Mary Blair, c. 1938. Courtesy The Michael Johnson Collection.

"End of the Day," watercolor by Mary Blair, c. 1938. Courtesy The Michael Johnson Collection.

South of the Border

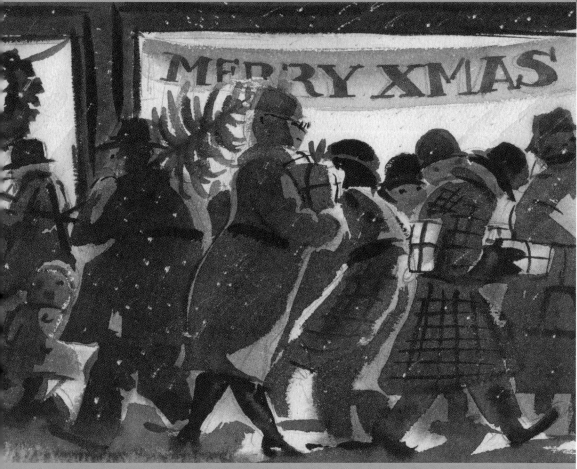

Mary Blair began at Disney as a $60-per-week sketch artist on Lady, *a dog story that eventually became* Lady and the Tramp *(1955). One watercolor of bustling, snow-blown Christmas shoppers, individualized by body shapes, posture, and props, resembles a* New Yorker *magazine cover. Blair's cinematic savvy offers a bird's-eye view of the scene, then stoops to a dog's-level perspective.*

*P*enelope, a story about a time-traveling girl, a grandfather clock, and personifications of the seasons and weather, marks the initial appearance of the big-headed "Mary Blair child." When a new script moved everything to Imperial Russia, Blair's delicate watercolors changed to flat colors (not lines) defining characters against single-tone backgrounds. Inside a castle, in rooms whose decor resembles a stage set, hot pink plays against cool mint—a preview of her modernist approach to color.[1]

Top: Mary Blair in 1941.

Above: A colorful toucan and parrot scamper along a Copacabana boardwalk. Collection of Dug Miller.

Left: Blair's earliest work for Disney: 1940 concepts for a dog story produced fifteen years later as Lady and the Tramp *(1955).*

Penelope, *a feature about a time-traveling girl, was never produced.*

For Penelope, Blair's style veered from delicate watercolors to bold gouache on single-color backgrounds.

"Baby Ballet" a pastel/watercolor sketch for a 1941 sequel to Fantasia *(1940).*

Baby Ballet, planned for a *Fantasia* sequel, features bigheaded babies in ballet tutus, in sugary children's-book watercolors with Degas-like pastel touches. One drawing, however—a semiabstract circle of five black dancers, their tutus underlit in primary hues—is refreshing in its pure shape, form, and coloring.

Blair experimented with styles and techniques, but essentially took art direction from supervisors Joe Grant and Sylvia Holland. Her drawings look like the work of three different artists. Her job, she said, was "interesting," but not enough to prevent her from quitting in June 1941 for "domestic life again," as she described it.[2] Lee said his wife "quit in disgust" and "wanted to stay home and paint."[3]

Two months later, however, Mary and Lee were on their way to South America with Walt, Mrs. Disney, and several studio artists. "From then on, everything was extremely interesting."

Below, left and right: Walt and Lillian Disney and various artists, including the Blairs, board a plane for Rio in August 1941 to research films and promote America's "Good Neighbor Policy."

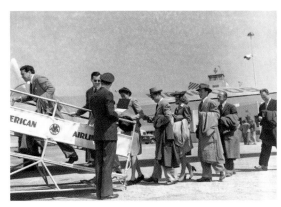

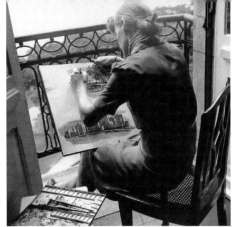

Because the work now involved planning a film from the very beginning, she felt in control and personally invested. "From forty-one on, I felt that I had found a place in the business,"[4] she said.

What Mary Blair found during three months in Brazil, Argentina, Bolivia, Peru, Ecuador, Guatemala, and Mexico City was her own unique artistic voice. The sheer gorgeousness of the art she created, its high quality and volume, is astonishing.

In painting after painting we are immersed (as was the artist) in the colors, rhythms, music, smells, and tastes of South America. Her on-site interpretations capture the life essence of the marketplace at Chichicastenango, the floating gardens of Xochimilco, the fishermen on Lake Titicaca, gardens, musicians, llamas, palm trees, basket-on-the-head chicken and flower sellers.

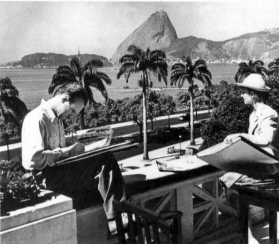

Top: Blair paints atop a Rio hotel.

Above: Mary and Lee Blair paint Sugarloaf Mountain in Rio de Janeiro.

Left: Mary Blair interprets the famous handicraft marketplace in Chichicastenango near Guatemala City.

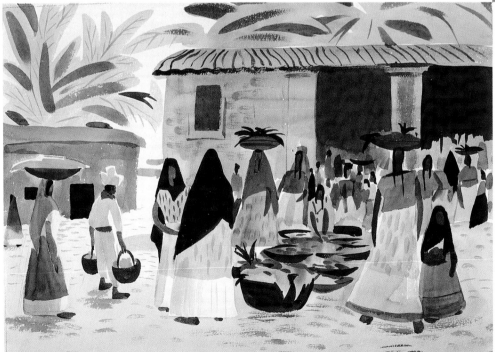

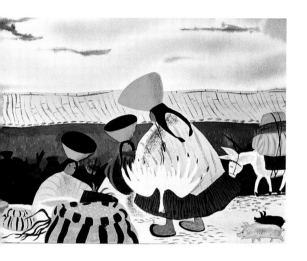

In Rio and Sao Paulo, [the Disney group] met composers both classical and pop (from Heitor Villa-Lobos to Ary Barroso); heard singers and poets; encountered painters and viewed their work; attended concerts, nightclubs, and festivals; went to zoos, farms, and beaches; and learned to dance the samba. In Buenos Aires, they attended barbecues and watched gauchos rope and break horses. They took balsa boat trips on Lake Titicaca, watched bullfights in Lima, and rode llamas in La Paz. Everywhere they went they drew, painted, and animated their impressions, and compared notes at makeshift studios in hotels. With the inundation of new sensations, inhibitions fell away, friendship's solidified, and group members became (and would remain) close. Even Walt loosened up and enjoyed himself so much, he literally stood on his head onstage in front of 2,000 schoolchildren at a special showing of Disney shorts at a theater in Mendoza, Chile.[5]

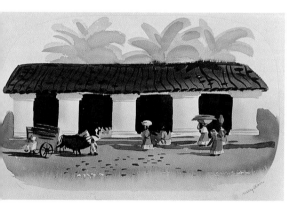

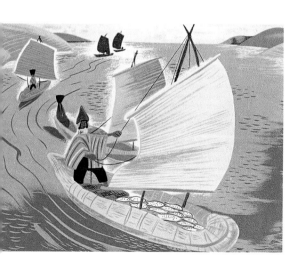

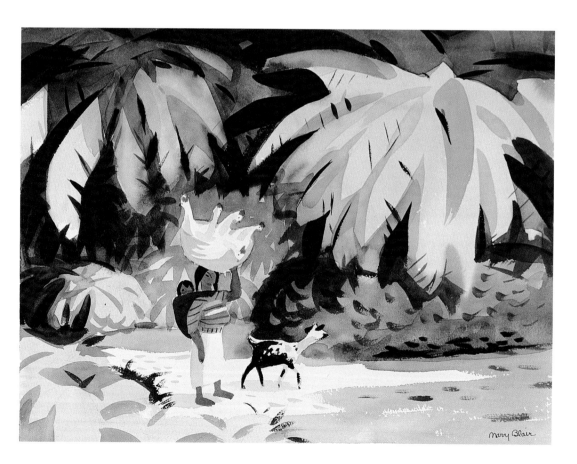

This page and opposite: Five views of South American life painted by Mary Blair on location in 1941.

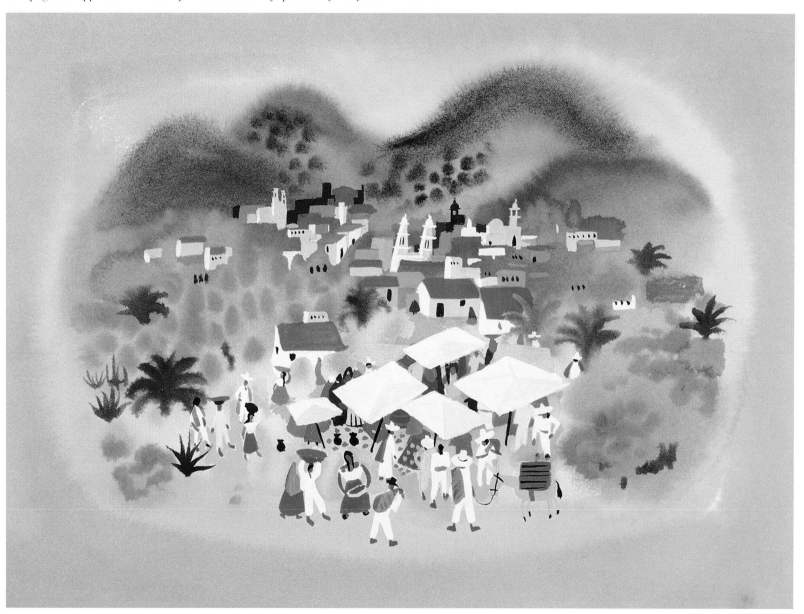

Mary Blair was deeply affected by the South American experience. She went inside herself to find how it *felt*, more than how it looked, and brilliantly communicated her emotions through imagery.

Her colors detonate in collagelike shapes and forms. Her compositions flow rhythmically and cinematically: balsa boats lead the eye from "long shot" to "close-up"; Peruvian hats in the foreground become "stepping-stones" to garment trading in the background. (Several of her paintings appear on screen in *Saludos Amigos*.)

Blair translated real-life observations into pure distillations of color and form. One almost hears a samba beat accompanying tiny Brazilian parrots dodging Technicolor rain, running along a Copacabana/Ipanema sidewalk that morphs into piano keys that, in turn, become rhythmic ribbons of the spirit of music itself.

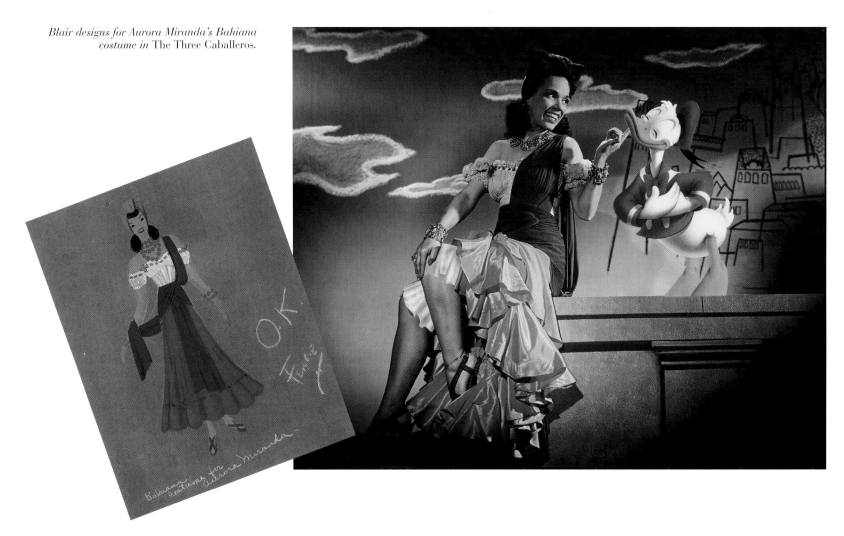

Blair designs for Aurora Miranda's Bahiana costume in The Three Caballeros.

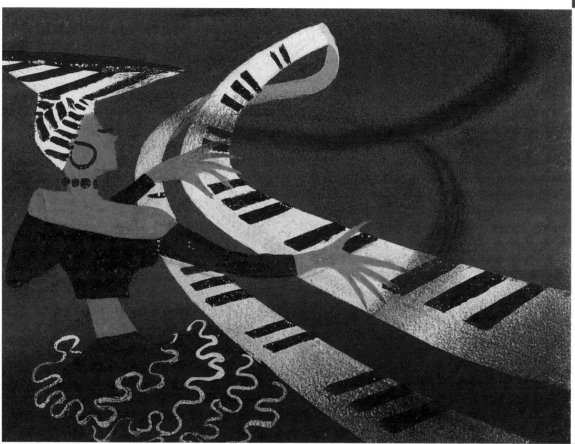

Dark to black backgrounds lend a certain mystery and make the characters' colors pop and crackle. "Brazil is really a very colorful country," Blair recalled years later. "The jungle colors and, as they say down there, 'the Black North,' have lots of colorful qualities. The costumes and native folk art are really bright and happy, like the same things in a country like Guatemala."[6]

Black dominates a quintessential Mary Blair design in *The Three Caballeros*, one of animation's most brilliant sequences: a little pink train (with one square wheel) chugs across a velvety black background studded with Day-Glo tropical plants. Blair, who painted all the production backgrounds for the sequence, felt it was the only time her "own artwork and style" appeared uncompromised in animation on the screen.[7]

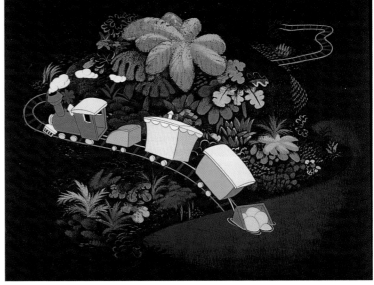

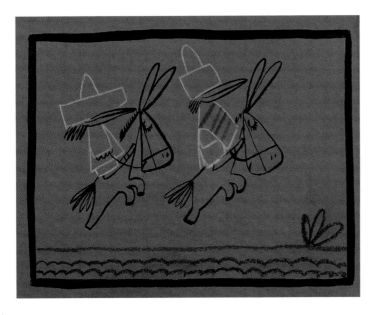

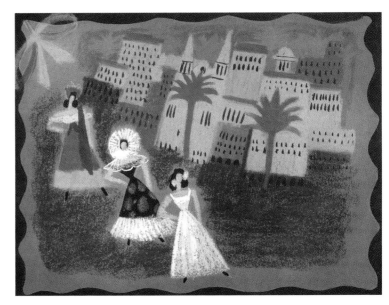

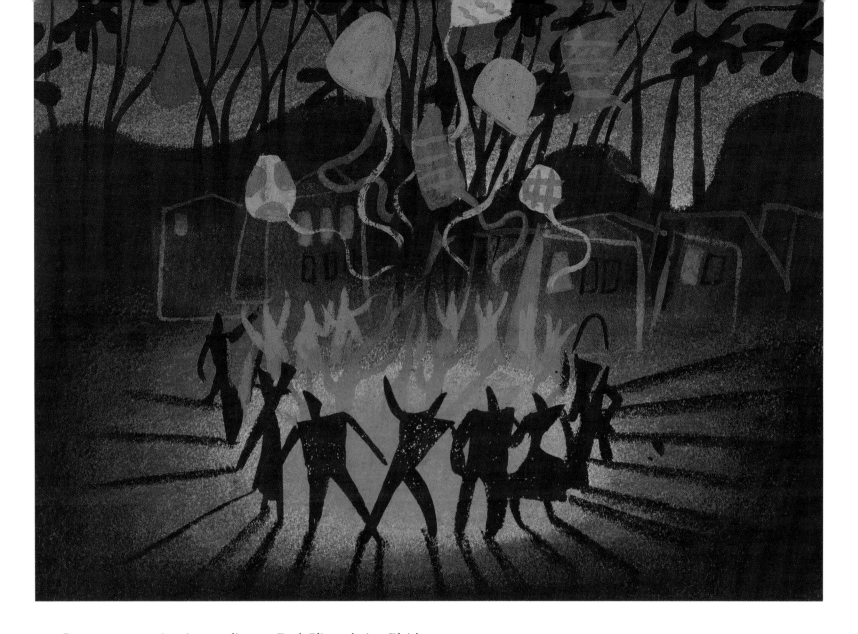

Contemporary animation art director Fred Cline admires Blair's

> *juxtaposition of neutralized and intense colors. Lots of artists make every-
> thing really bright or really mute. She mixed both with a graphic sense with-
> out hardness. Her shapes are very organic but graphic. It's different. You
> know you're looking at something only Mary Blair did.*[8]

Saludos Amigos began a new era of Disney color and styling, which enjoyed a glorious run
through the postwar years. "Walt said that I knew about colors he had never heard of before,"
boasted Mary Blair, the artist who led the way.[9]

Surprise Packages

When America entered the war, Mary Blair worked primarily on the South American features. In December 1942 she traveled to Mexico on a "survey trip," and in March 1943 flew to Cuba for two months of "preliminary research."[1]

After Havana, she visited Lee who, since October 1942, had been a lieutenant in the Navy Photo Science Lab at Anacostia near Washington, D.C.[2] During the war years, she periodically stayed with him in Galesville, Maryland, in a large house with a dock and crab traps on Chesapeake Bay, where the Blairs enjoyed sailing.

But she always returned to their strikingly modern Los Angeles house, designed in 1939 by architect Harwell H. Harris, which remained her base of operations.[3] It was the beginning of years of "commuting" (initially by train, then air) between eastern-based Lee and Disney in the west.

In addition to films, Blair was busy with "extracurricular" projects. In October 1943,

Top: Mary Blair during World War II.

Above: Latin American parrots in a Technicolor tempest. Collection of Dug Miller.

Left: Concept art for the "Two Silhouettes" sequence in Make Mine Music *(1946).*

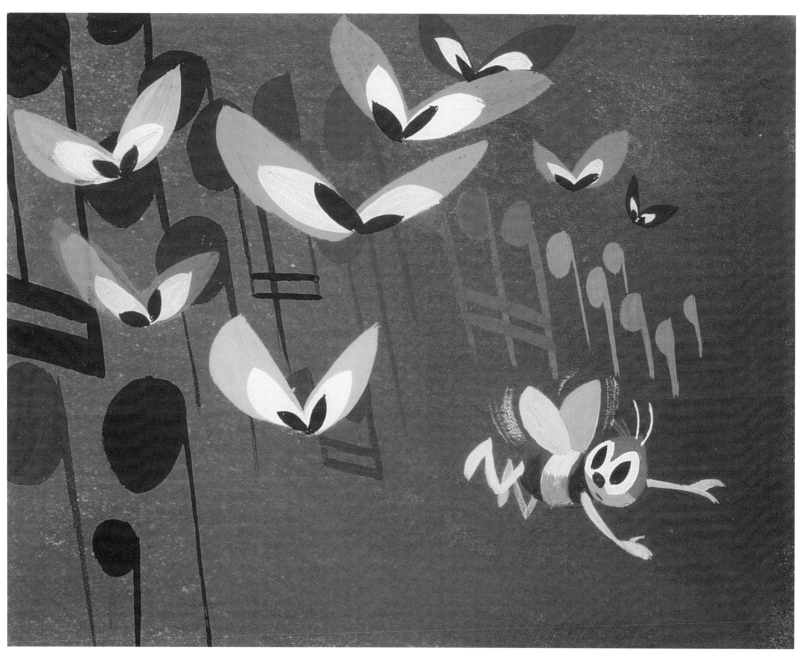

The jazzy "Bumble Boogie" from Melody Time *(1948)*.

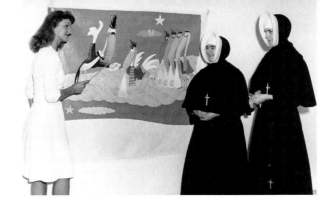

Right: Mary Blair displays a stork mural to nuns from St. Joseph's Hospital's maternity ward, Burbank, 1943.

Below: Two wall murals painted in 1945 for Carmen Miranda's Beverly Hills living room. Collection of Mike Gabriel.

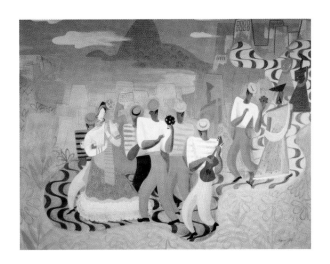

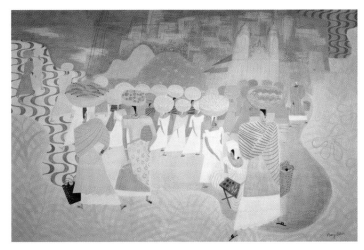

she designed and painted a mural for the Hollywood Canteen and the new St. Joseph's Hospital Nursery in Burbank, California. In December, her South American watercolors were exhibited at her alma mater, San Jose State College.[4]

Disney commissioned her to paint two murals for the Beverly Hills home of musical movie star Carmen Miranda, whose sister, Aurora, was featured in *The Three Caballeros*. The colorful designs, full of rhythmic patterning, depict musicians samba-ing along a Rio sidewalk, and Bahiana fruit sellers balancing baskets on their heads.

Ninety-four percent of all footage produced by Disney from 1942 to 1945 was under government contract for training and propaganda films.[5] During that time, he looked toward a future whose bleak finances would not allow an immediate return to animated features. "I knew the diversifying of the business would be the salvation of it," he concluded.[6] Mary Blair became integral to Disney's plan to expand his product line.

First came "package" films: unrelated cartoon shorts strung together into a feature. Although wildly uneven in quality, those shorts with Mary Blair's art direction have an exciting experimental quality. Fine examples are the expressionistic tone poems "Without You" and "Two Silhouettes" in *Make Mine Music*; the surreal "Bumble Boogie" and the psychedelic "Blame It on the Samba" in *Melody Time*; "Once Upon a Wintertime," an adaptation of Currier and Ives;

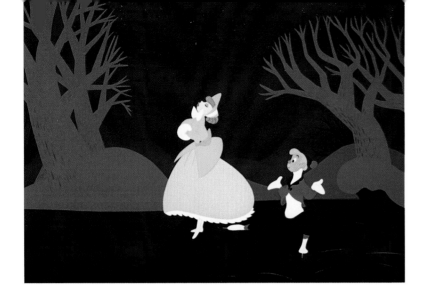

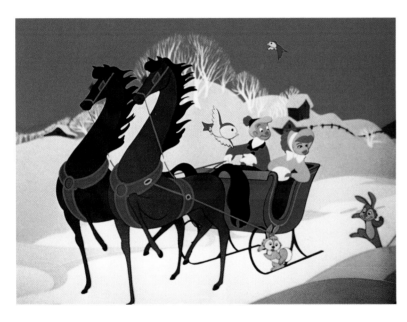

and "Johnny Appleseed," which echoes the regionalist painting style of Thomas Hart Benton and Grant Wood.

Half a century later, master animator Frank Thomas remembers Blair's "Appleseed" artwork as "some of the greatest things I'd ever seen for an animated feature. Just handsome, handsome drawings! The colors, the shapes, they way they all went together."[7] Blair's color and styling in *The Adventures of Ichabod and Mr. Toad* wonderfully contrasts Sleepy Hollow's bright autumnal colors and midnight spookiness.

Live-action films soon became another component of the studio's output under Disney's diversification program. Disney's early live-action films include animation sequences within the story, so it was only natural that the studio head looked to Blair for concepts.

Two concept paintings for The Adventures of Ichabod and Mr. Toad *(1949). Collection of Glad Family Trust.*

Two concepts for the "Johnny Appleseed" sequence from Melody Time.

Blair's color/styling suggestion for a scene in "Johnny Appleseed" and (opposite page) how the background painter closely matched it.

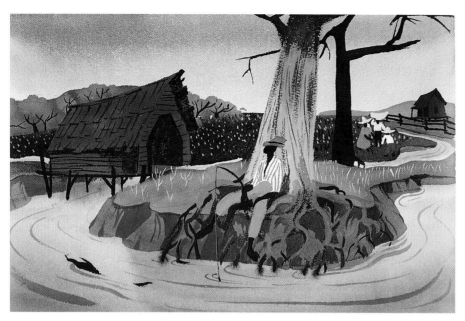

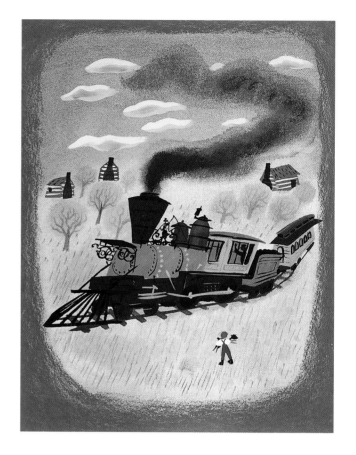

Above: A 1944 exploratory painting made by Blair on location in Georgia for Song of the South *(1946).*
Right: A fanciful train chugs through a rural setting.

In fall 1944, Blair spent a week in Atlanta and nearby rural Georgia locations doing preliminary research for *Song of the South* (1946).[8] Spring 1945 found her in New York libraries and museums researching *Alice in Wonderland* (which was under consideration as a Ginger Rogers vehicle),[9] then in Indiana soaking up farm atmosphere for *So Dear to My Heart* (1949).[10]

Her plein—air paintings of Georgia cotton and cornfields, dusty red roads, wooden shacks, plantation mansions, and burning sunsets were adapted—in high-key hues—into *Song of the South*'s special-effects sequences: live-action Uncle Remus interacts with cartoon critters against a Mary Blair blue sky along a Mary Blair burnt sienna road amid Mary Blair greenery.

As Disney nervously edged into live-action films, he called upon Blair to expand her influence by conceptualizing sets and costumes. Her atmospheric detailing of crucial *Song of the South* live-action scenes, painted with a low-key palette and classic watercolor techniques, recalls Pruett Carter, as does her poignant depiction of the isolation of the boy protagonist and the contrasting lifestyles of black and white folk during Reconstruction.

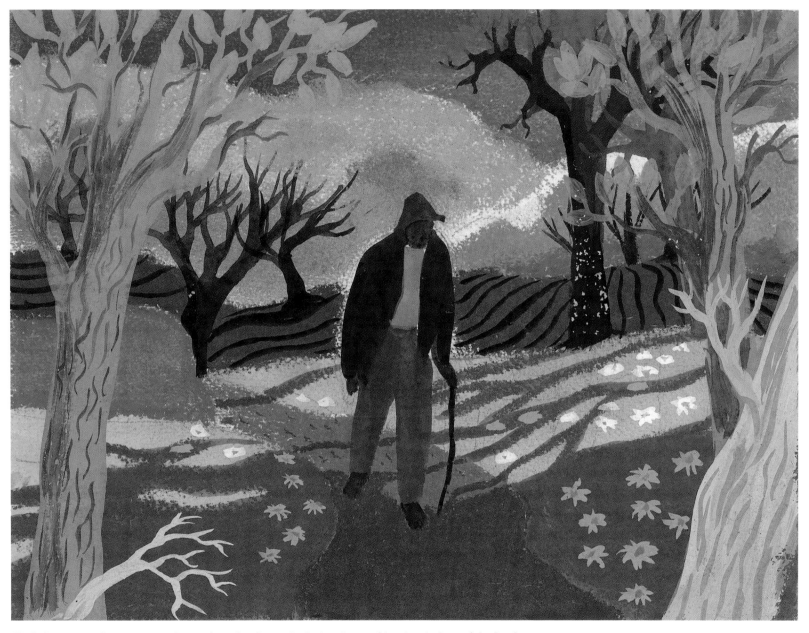

Uncle Remus in a fantasy setting, later adapted to live-action/animation combinations in Song of the South.

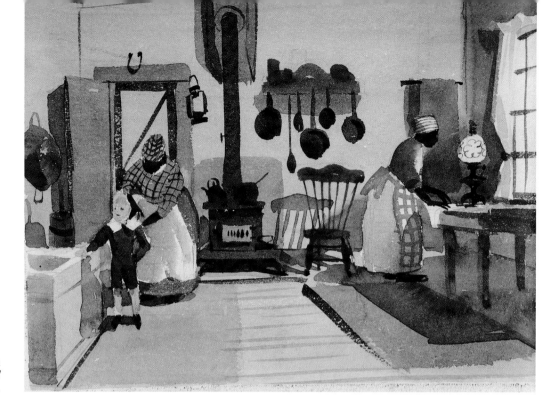

This page and opposite: Blair's Song of the South sketches suggest ideas for costumes, settings, and mood for both live-action and animation sequences.

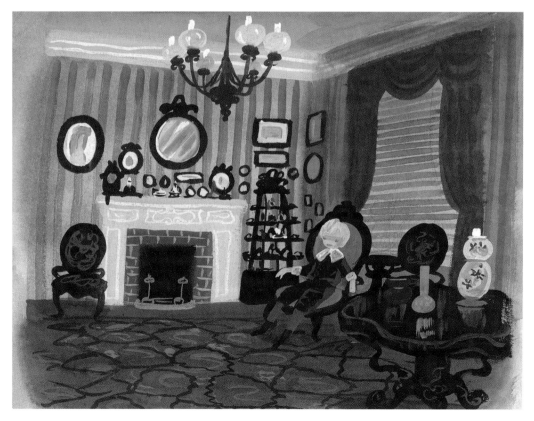

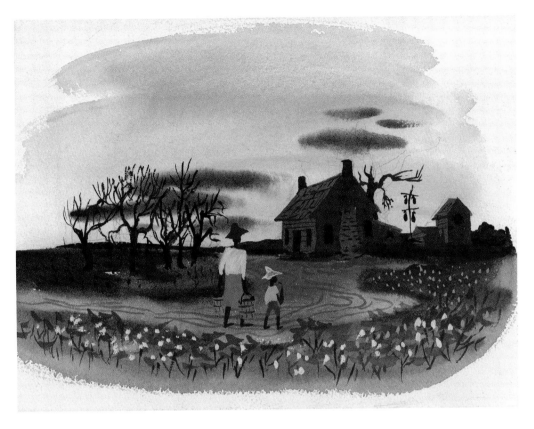

Her art is even more remarkably gorgeous for *So Dear to My Heart*. A nostalgic valentine to turn-of-the-century rural America, the film was especially dear to Walt Disney: "Why, that's the life my brother and I grew up with as kids out in Missouri."[11]

Blair based her visualizations on quilt patterns. On April 20, 1945, she wrote from Maryland to Walt:

> *I have found a good book on American quilts and bought it for the studio. I think I should make a quilt now after reading it. It seems that quilt making is a revived art in this country now, which fact adds more value to its use as a medium of expression in our picture.*[12]

Decorative quilt patterns weave throughout Blair's allegorical paintings, sometimes explicitly, as in a childlike farmscape with vegetables made of dots, cross-hatching, squiggles, and dashes. A quilt is suggested by placing color patches next to one another (a fence resembles stitching). Her colors are extraordinarily rich: hot pink and rose madder amid golden yellow, ochre, and oranges, expertly juxtaposed with unusual tones of grayed violet, purple, alizarin crimson, and salmon.

This page and opposite: Blair based So Dear to My Heart *(1949) inspirational sketches on quilt patterns.*

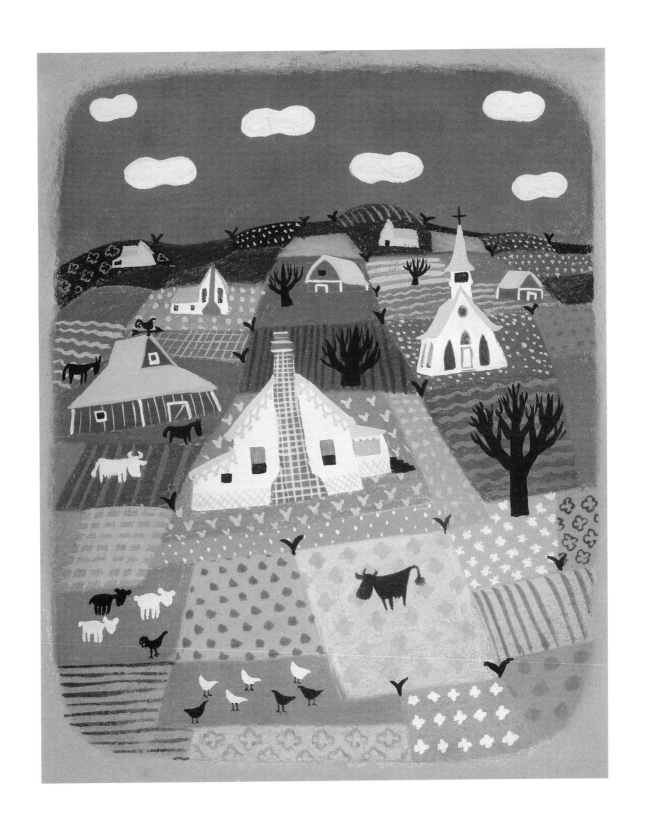

SURPRISE PACKAGES

Blair's sophisticated application of folk or primitive motifs recalls Grandma Moses (1860–1961), the superannuated farmwife whose naive paintings were an extension of her embroidery (or "yarn picture") skills.[13] As was true of Moses' work, the soothing nostalgia and traditional American values expressed in Blair's paintings and Disney's film appealed to a public fatigued by World War II and frightened by the new Atomic Age and the possibility of nuclear annihilation.

Blair's sensual, spheroid, biological, abstract forms communicate solace, comfort, joy, and pleasure to the viewer. Combined with Walt Disney's paean to the nation's heritage and values, her art became a reassuring expression of faith in, and hope for, America's future.

Seasons may change in rural, turn-of-the-century America, but the church remains constant.

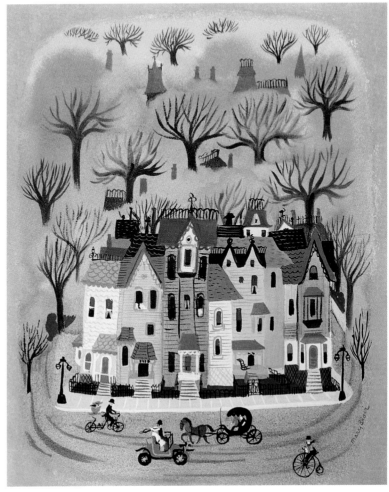

By 1948, Disney decided to reenter the feature-length animated cartoon arena. *Cinderella*, followed by *Alice in Wonderland* and *Peter Pan*, released between 1950 and 1953, bear Mary Blair's artistic imprint in varying degrees.

The last animated features she worked on, these three films represent a renaissance of the form and the beginning of a period of unprecedented growth and success for the Disney studio.

Blair's So Dear to My Heart *paintings depict country life in (left) cool spring and (right) hot Indian summer.*

Chapter Four

The Big Three: Cinderella, Alice & Peter

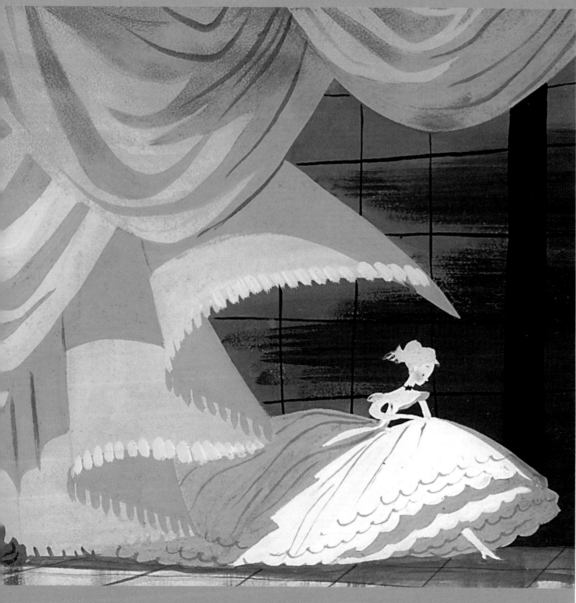

Lee Blair declined Walt Disney's offer of reemployment after his Navy discharge.[1] The offer was not job specific, and Lee was leery of competing with his own wife at a place where she was so well regarded. "He was at Disney before Mary and did very well," observed animator-designer Marc Davis. "When Mary came, she became terribly important to Walt, and Lee less so."[2]

By January 1946, Lee and two partners formed Film Graphics, a TV commercial and industrial film company in New York City. "Lee wanted to grow on his own—be his own boss," notes family friend Neil A. Grauer. "Lee got in on the absolute ground floor of television [and] soared to the heights."[3] His business took off, and soon he was "rolling in dough . . . making films and TV spots."[4]

By May 1946, Mary was pregnant (at age thirty-five) with the couple's first child, Donovan, and they moved to an apartment

Top: Mary Blair, c. 1950.
Above: The Darling children fly to Never Land in Peter Pan (1953).
Left: Cinderella flees the palace in Cinderella (1950). Courtesy Howard and Paula Lowery.

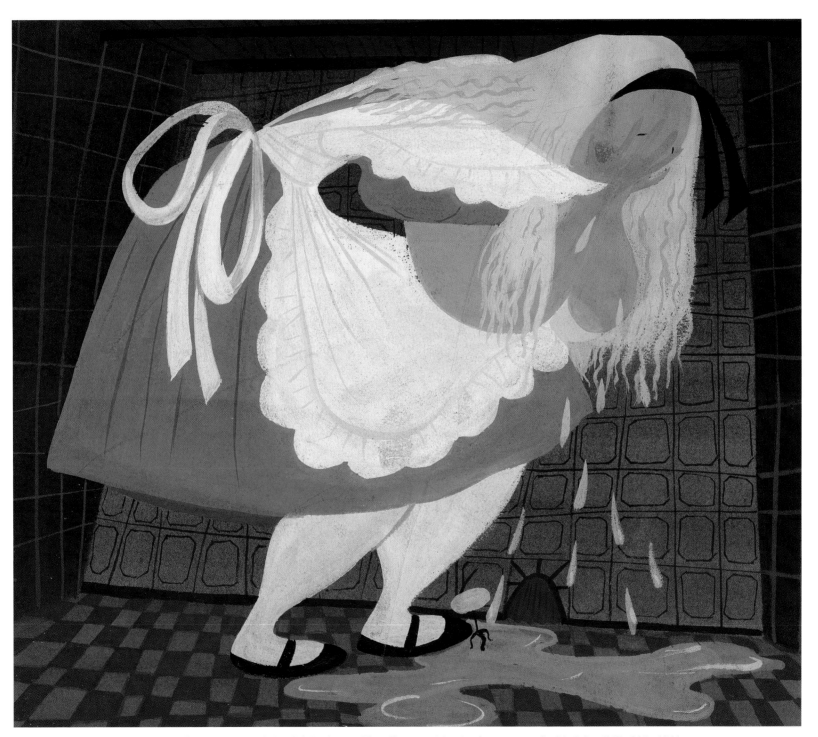

Blair's bold shapes and patterning for Alice in Wonderland *(1951) resemble collage, anticipating her concepts for* It's A Small World *in 1964.*

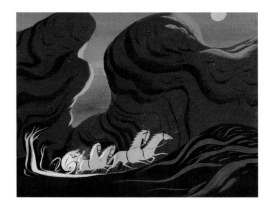

off Fifth Avenue in New York City. In 1950, the Blairs' second son, Kevin, was born, and they built a house in Great Neck, Long Island, designed by architect Frank Nemeny. Alice Davis remembers "this beautiful house, with an all-glass entrance hall overlooking a pond."[5]

Walt Disney visited the house at least once to "check on my work when I was working on *Cinderella*," recalled Mary, who now traveled to the studio in Los Angeles infrequently.[6] She remembered how Walt had "a strong feeling of likes and dislikes" regarding her concepts. She could "always sense when Walt didn't like something. He usually didn't say anything. At those times I would just keep quiet. When he liked something, he was usually all smiles. All I know is that [generally] he liked what I did. I got along with him all right."[7]

Cinderella retains much of the romantic color palette and whimsical attitude found in Blair's original sketches. Were palace chambers and staircases ever grander, château living rooms more pompous, or attic quarters more dank and cramped?

Her ideas for mood and emotional "colors" are there as well. Cinderella, primping in a gilt mirror, is a plucky servant girl in a tattered dress, who places a rose in her hair to improve her appearance and lift her spirits. Later, in an airless garret, her back to us (the picture of wan vulnerability), our heroine gazes out a tiny window toward a castle and a happier future, ignoring her shabby room and the troubled present (a reminder of Blair's self-portrait circa 1934 intently painting herself).

The sequence in which glass slipper–shod Cinderella flees the prince's ball at midnight has dramatic sweep: the curtains undulate in voluminous folds as she dashes out of the castle; the shrubbery rushes ominously alongside her escaping coach; the blood-red capes of the black-silhouetted horsemen who pursue her raise a silent siren of alarm against an indigo sky.

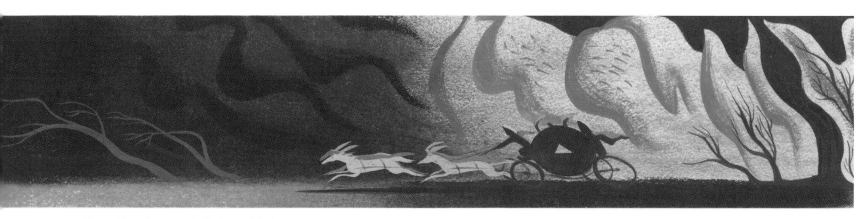

Top, middle, bottom: Rhythmic, undulating shapes and an exciting use of light and shadow "animate" Cinderella's carriage as it dashes home before midnight.

THE ART AND FLAIR OF MARY BLAIR

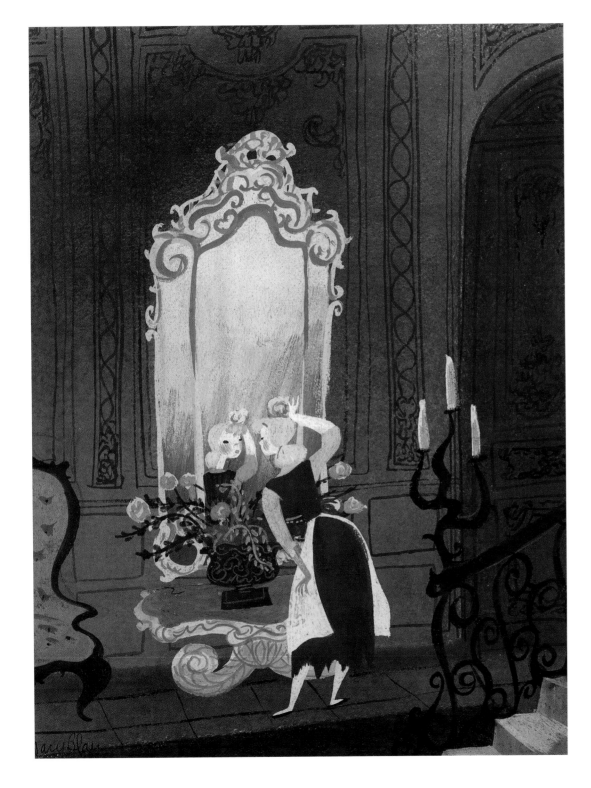

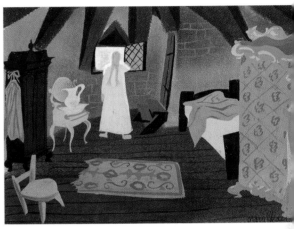

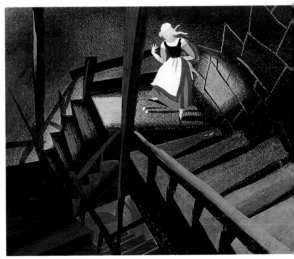

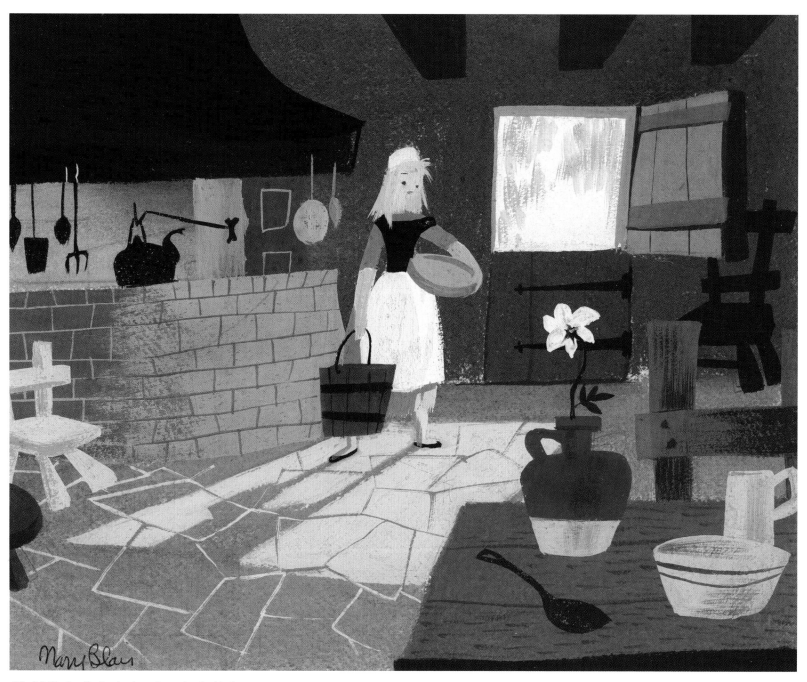

Wistful Cinderella begins her chores in the kitchen.

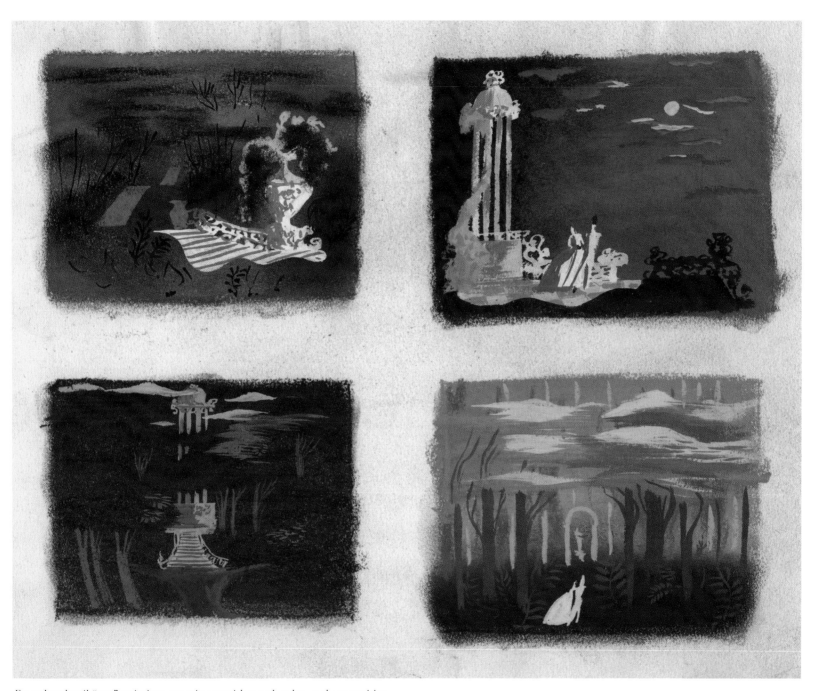

Four thumbnail "test" paintings experiment with mood, color, and composition.

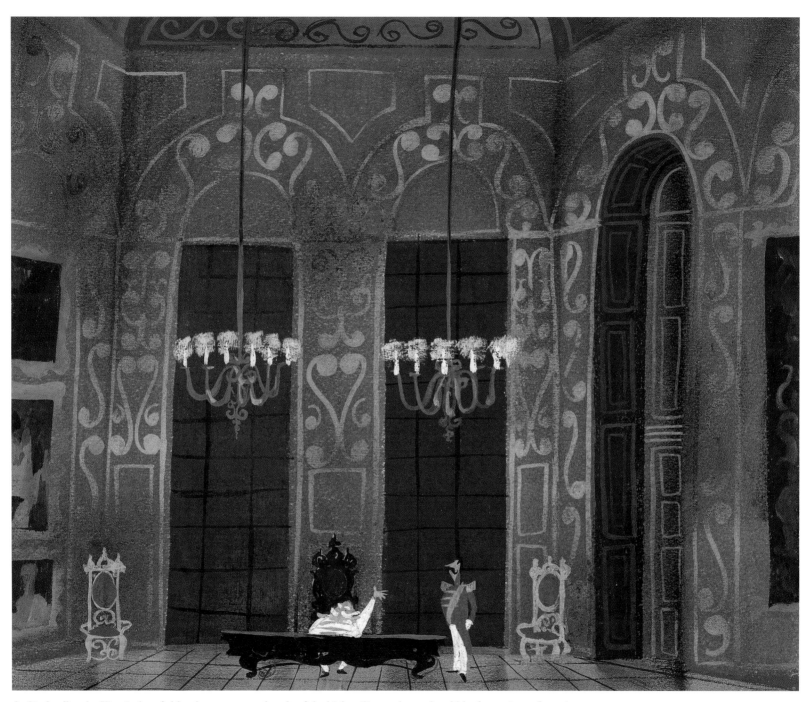

In Cinderella, *the King is dwarfed by the exaggerated scale of the high ceiling and grand, gold leaf trappings of royalty.*

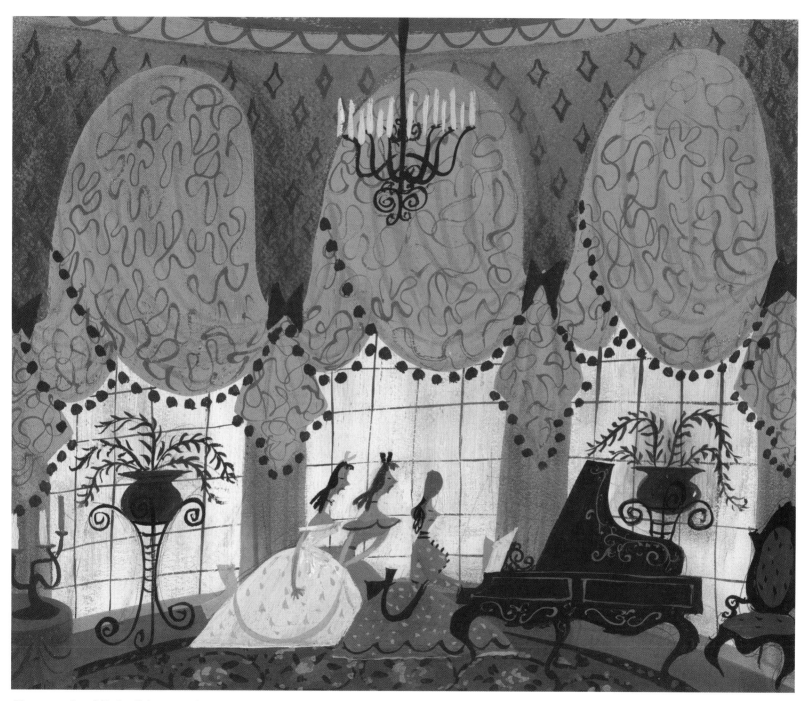

The pomposity of Cinderella's stepmother and stepsisters—singing off-key at a harpsichord—is mirrored in the grandiose decor.

Blair color-keyed and suggested staging for every important sequence in the film and some in discarded ones as well (such as the stepsisters' singing lesson with a, literally, flighty maestro). Her imaginatively surreal paintings for Cinderella's dream (in which she commands seven housemaids of her own) rival the visual pizzazz of *Dumbo*'s "Pink Elephants" sequence and the little train in *The Three Caballeros*.

But Disney was cautious with his comeback feature. Outré dream sequences were cut, and the familiar, rounded Disney house style for characters took precedence over Blair's sleek stylizations. Her refreshing designs for Cinderella, the Prince, Stepmother, Fairy Godmother, and other characters stand in sharp contrast to the final versions, which were slavishly transferred from live-action models.

Blair's streamlined cartoon designs for Cinderella *characters—the Prince and Cinderella, Fairy Godmother, stepsisters, and an excitable singing teacher—were rejected.*

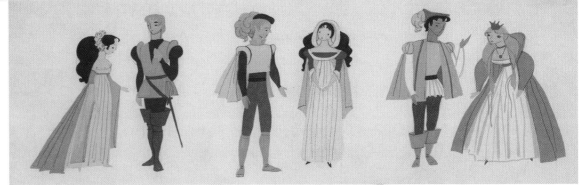

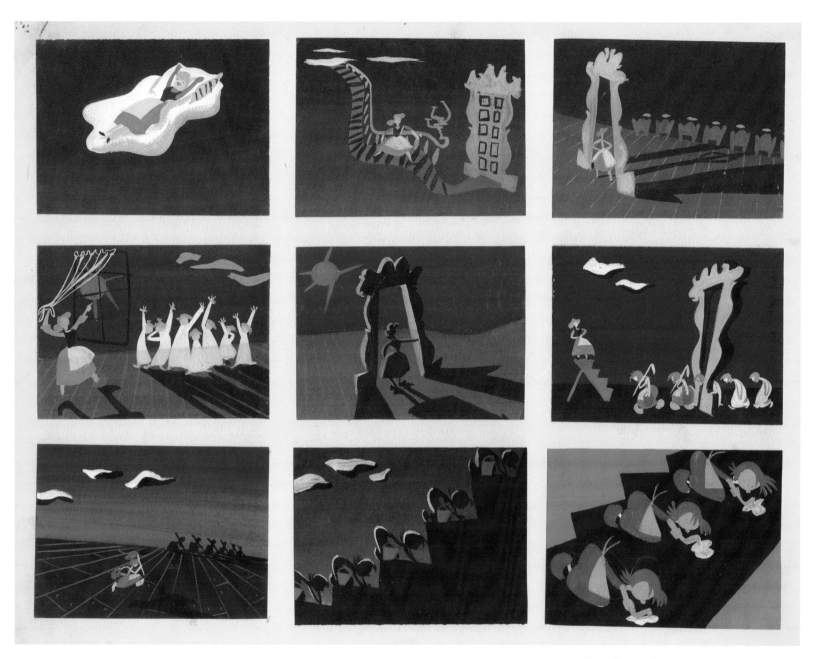

Surrealist touches appear in gouache sketches for a Cinderella *dream sequence, later cut.*

"The *Cinderella* characters could have been pushed more [design-wise]," notes Michael Giaimo, art director of *Pocahontas* (1995), "but her environmental sketches—the whimsicality of the château, interiors, couch, piano, curtain, and the color—those translated beautifully."[8]

In getting "Mary" on the screen, there was, more often than not, a design disconnect between characters and settings. One of the most consistent visual statements is found in "Once Upon a Wintertime," where both character designs *and* animation match Blair's stylized backgrounds. Usually, however, rounded human and animal characters were incongruously placed against flat color or stylized backgrounds.

"As strongly as she influenced Walt and the design of the characters, the colors, the whole concept of the thing, it didn't take," comments Frank Thomas.[9] It didn't "take" completely because Disney feared losing the believability that his mass audience expected.

"Mary Blair" *is* found in a setting, a color, a costume, a concept, or piece of staging, often uncomfortably attached to fully dimensional, traditional-style animation. The reasons were both technical and personal.

"If you moved Mary Blair's things," veteran Disney art director Ken Anderson once explained, "the question is whether it would be as wonderful as it is static."[10] Marc Davis, however, believed that "[t]his woman was an extraordinary artist who spent most of her life being misunderstood. All the men that were there [at Disney], their design was based on perspective. Mary did things on marvelous flat planes. Walt appreciated this and wanted to see this, but he, not being an artist himself, was never able to instruct the men on how to use this. . . . [I]t was tragic because she did things that were so marvelous and never got on the screen."[11]

Animator Ward Kimball put it succinctly: "She would inspire people, but her drawings were bastardized."[12] It is clear that Disney supported her only up to a certain point.

Many elements of Blair's ideas for costumes, colors, mood, composition, settings, and decor patterns were adapted for the film.

In *Alice in Wonderland*, a project that had fascinated and confounded Disney since his earliest days as a filmmaker, a considerable amount of "Mary" does appear on screen. The "March of the Cards," derived from dozens of Blair's small paintings, is as visually exciting as anything in the Disney canon.

She based her imagery on John Tenniel's illustrations for the original Lewis Carroll books. But again, "Walt would not let us go completely in that direction," Blair recalled, "but we did incorporate some pure black, white, and gray line details in the backgrounds."[13]

The visually exciting "March of the Cards" in Alice in Wonderland *originated in Blair's concept paintings.*

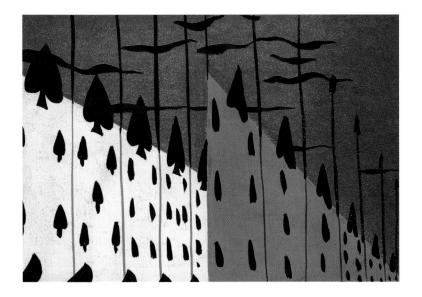

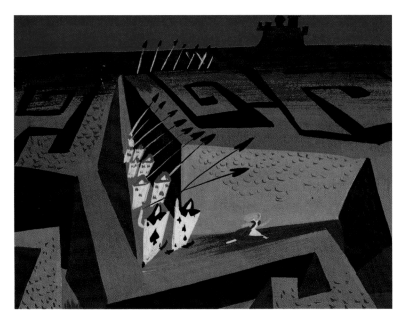

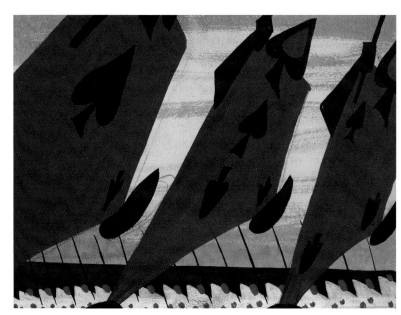

Blair's "March of the Cards" sketches display the dynamic staging and choreography, colors, and semiabstract imagery seen on the screen. Collection of Dug Miller.

Ward Kimball, who animated the Mad Tea Party, said he "got this idea that we'd have just the characters in the tea party in full color on the cels, but the backgrounds would be done like Tenniel in black-and-white. [Mary] thought it was a great idea." But "when she showed it to Walt he gave it the thumbs-down. [Walt said,] 'You tell Ward just to give us that good old Kimball animation.'"

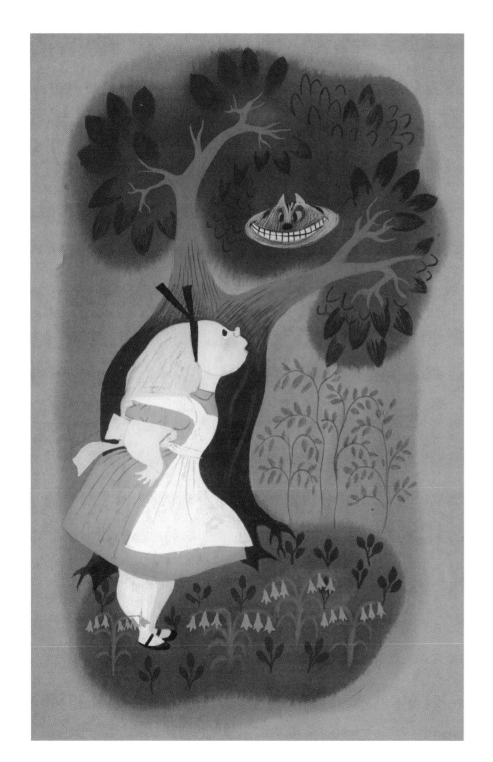

Left: Alice meets the magical, mad Cheshire Cat. Theresa Wiseman Collection.

Above: Actress Kathryn Beaumont, Alice's voice, stands before a storyboard of Mary Blair concept art.

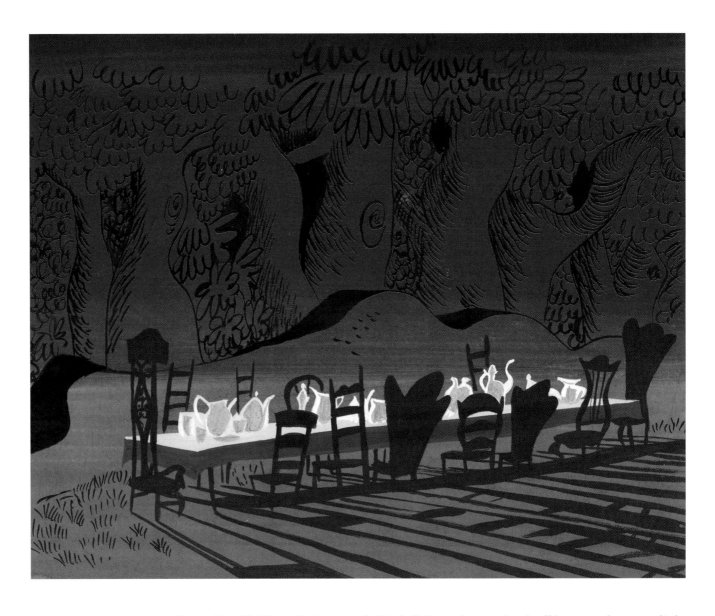

Long black shadows amid gloomy woods lend the setting for the Mad Tea Party a sinister, nightmarish cast.

Regarding Blair's work in general, Kimball "was always pissed off because the great little paintings she did, nobody ever used."[14]

Mary Blair's sensibility pervades *Alice*'s leaf patterns, shrubbery, settings, props, characters, costumes, and color. She envisioned Wonderland as a dark psychological dreamscape (the story *does* take place down a rabbit hole, underground). Scenery for Tulgey Wood (home of the Cheshire Cat), the Garden of Live Flowers, and the Mad Tea Party are shadowy to black; against them the brightly colored characters pop out or are isolated in pools of light.

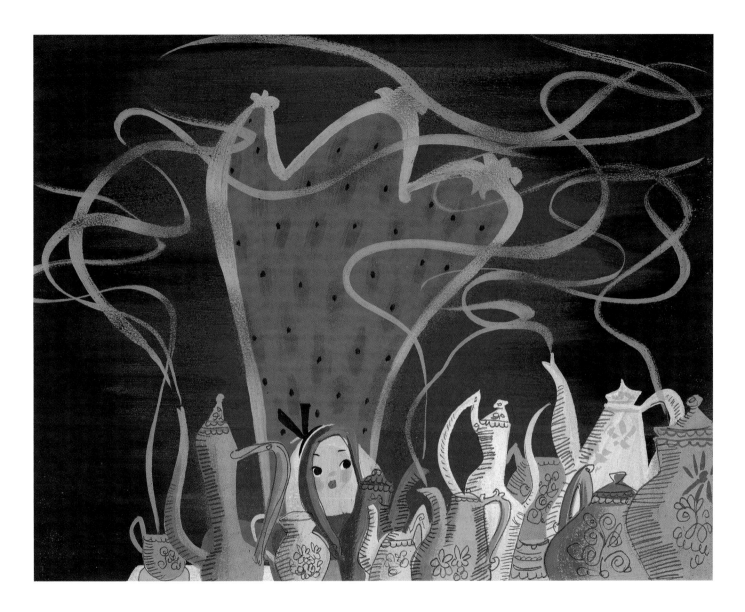

Animation director Mike Gabriel admires how well her characters "read": "Primary color, secondary color with a complementary accent against a muted complement in the background. When you do that, [the image] sings like a million bucks."[15]

Blair's wit, whimsicality, and soulfulness—her empathy for young Alice—dwell in many a sketch. A quintessential image: Alice, floating through an esophagus-shaped tunnel lined with Victorian objects, unconcerned but surprised to see herself upside down in a mirror. "Well!" wrote Carroll of Alice's thoughts at that moment, "After such a fall as this, I shall think nothing of tumbling down stairs!"

Alice is surrounded (and trapped) by threatening teapots, their lasso-like steam, and an aggressively large chair that resembles a mouth about to snap shut.

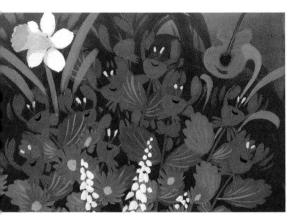

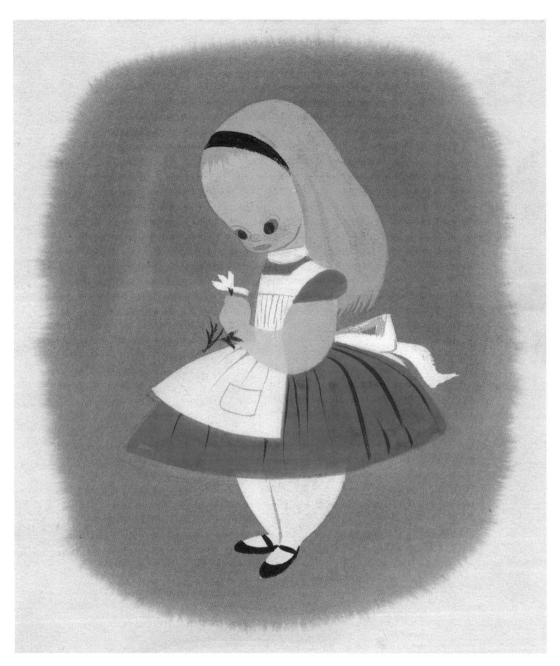

Left top: Blair's ideas for the live flower sequence included literal crabgrass.

Left middle: "All ways here are the Queen's ways," including shrubbery that conforms to her heart shape.

Left bottom: The recitation-mad twins Tweedledee and Tweedledum.

Above: Mary's Alice, a picture of childhood innocence.

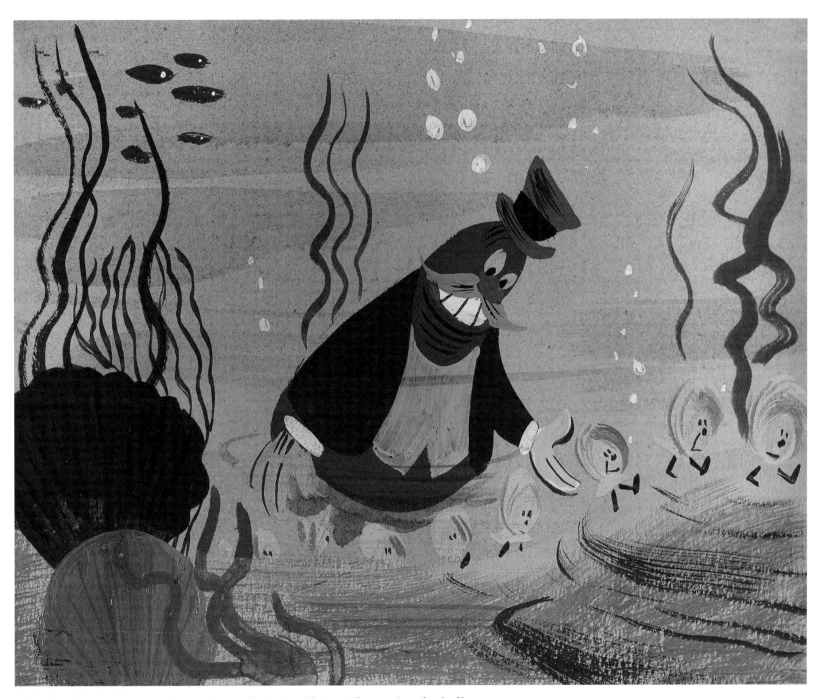

The walrus dupes naïve oysters in one of scores of paintings Blair rapidly turned out for the film.

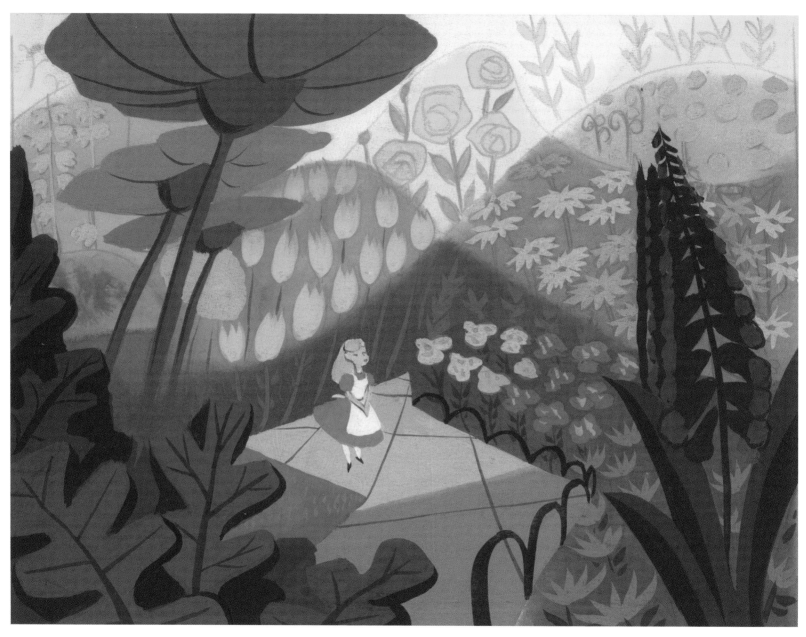

Little Alice lost among Wonderland flowers—a brilliant Mary Blair portrait full of rhythm, color contrasts, and emotional empathy.

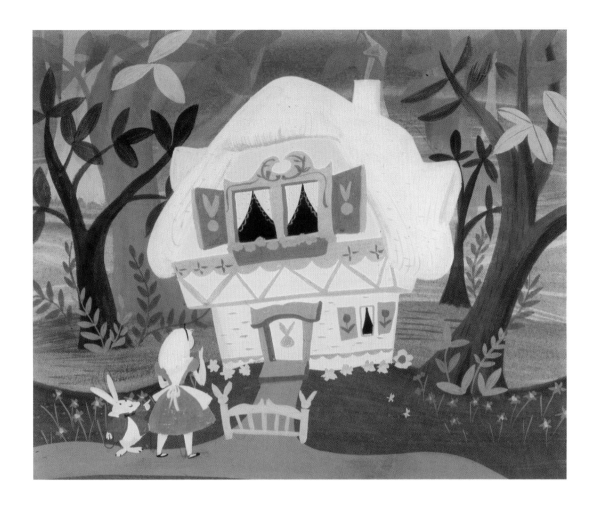

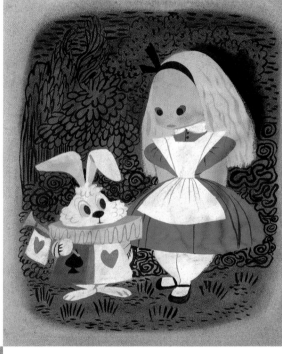

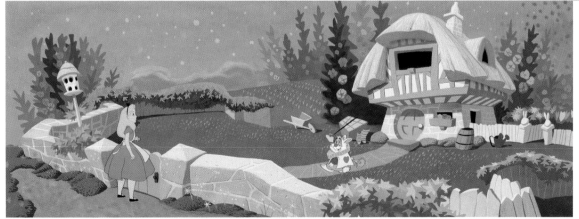

Above left: Alice and White Rabbit's house.

Above right: Alice and White Rabbit in a quiet moment; Blair borrowed the background patterning from John Tenniel's original Alice book illustrations.

Left: Cels against an original production background from Alice in Wonderland show how Blair's designs were both incorporated and altered. Courtesy of Howard and Paula Lowery.

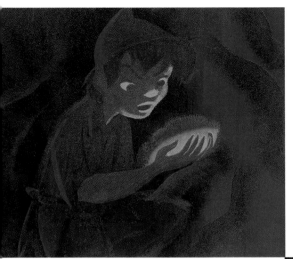

For *Peter Pan*, her final feature, Blair's inexhaustible well of creativity continued gushing forth. "Mary, of course, was a genius in what she did," says legendary storyman Joe Grant. "She'd sit there and knock out one piece after another at an amazingly rapid pace. But she seemed to absorb whatever idea we had and come through and give us a visual."[16]

An impressive component of Blair's concepts for *Peter Pan*'s world of pixies, pirates, and Lost Boys is her mastery of mood through dramatic lighting. Golden sunset rays fall across the striped mainsail of Captain Hook's galleon as it moves out to sea; a rosy dawn and a lantern's glow illuminate the pirates and their captives as they head back to the ship; the moon is reflected in the water across a Never Land inlet, and silvers the jungle foliage; the Lost Boys' cozy underground hideaway is lit solely by a tree-root candelabrum and a glowing fireplace; Indian tepees on a hillcrest are silhouetted by white, hazy moonshine; the glow from a golden flying vessel is so incandescent that it darkens the moon.

Above: Peter Pan holds a wounded Tinker Bell. Collection of Glad Family Trust.

Right: Captain Hook's pirate ship transformed into a golden dream boat. Courtesy of Howard and Paula Lowery.

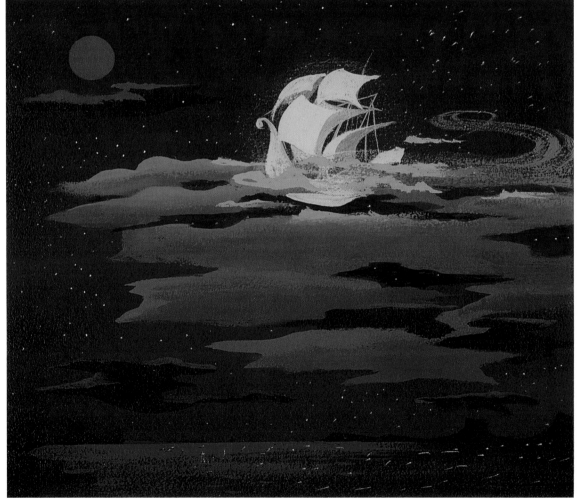

THE ART AND FLAIR OF MARY BLAIR

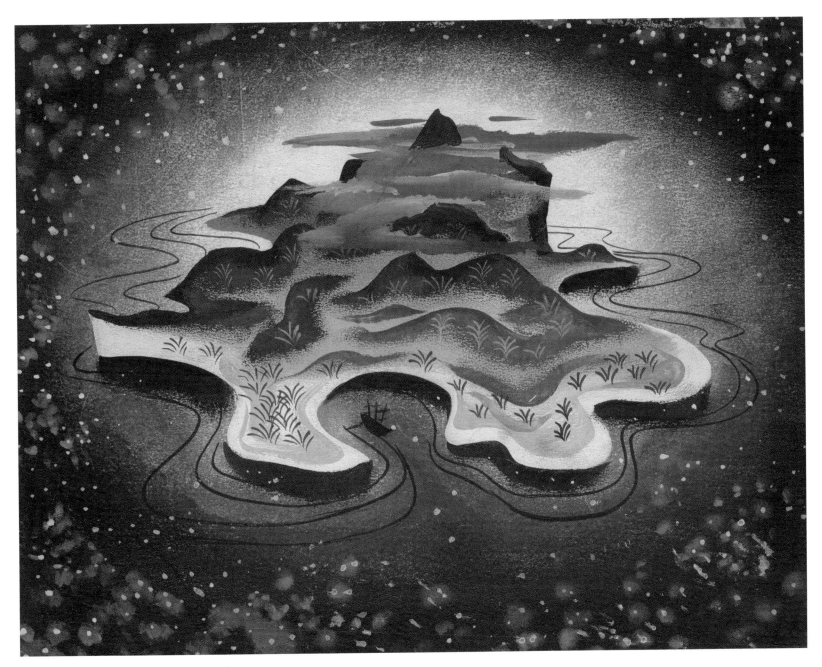

Mary Blair's abstract shape for Never Land.

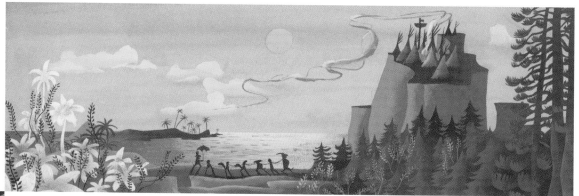

Blair's mastery of light evokes different
times of day and moods at various
Never Land locations.
Courtesy Howard and Paula Lowery.

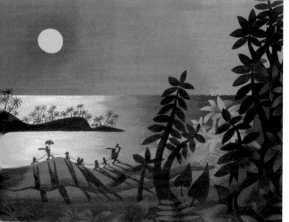

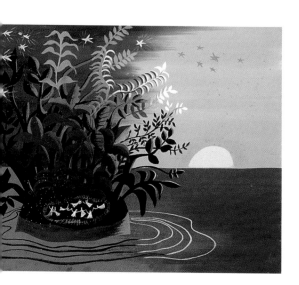

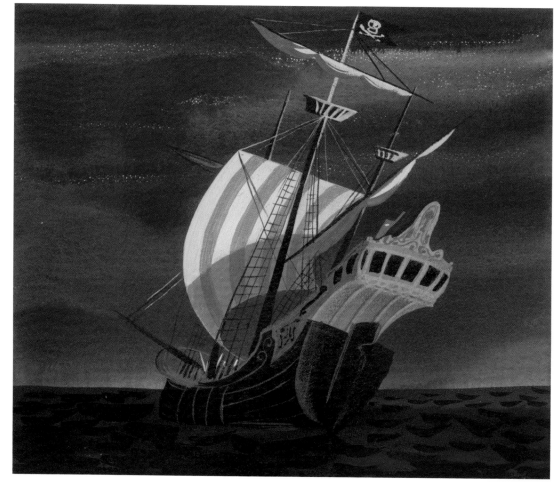

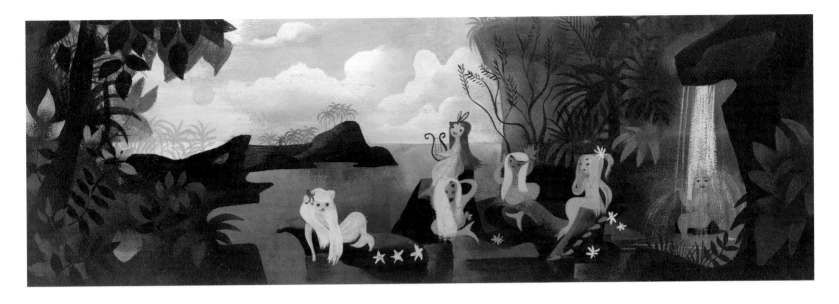

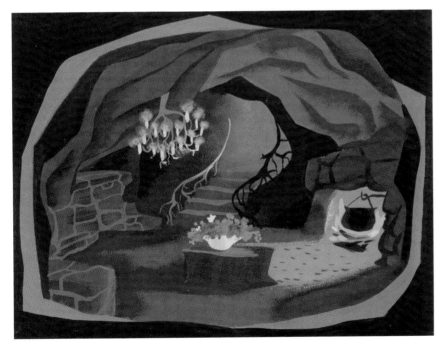

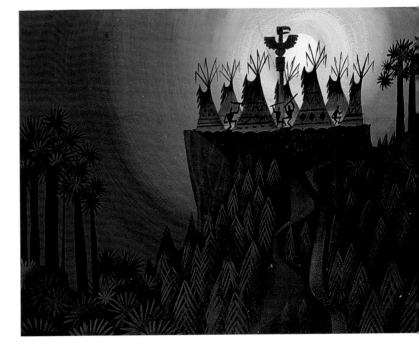

Biomorphic shapes lead the eye and "animate" Blair's compositions; be it a lineup of beauteous mermaids, the cozy underground grotto of the Lost Boys, or a forest advancing toward a mountaintop full of tepees.

Above left: Courtesy of Howard and Paula Lowery.

Above right: Collection of Michael Giaimo.

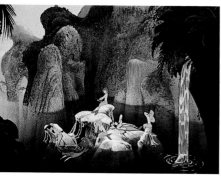

Blair's use of light inspired odd and original color schemes: a weird, pale green sky over magical Mermaid Lagoon; deathly white Skull Rock against ashen clouds as Captain Hook (tiny in a rowboat) approaches. (The only bright color is a smudge representing Hook's blood-red hat plume, symbolic of his savagery.) Tinker Bell, injured when rescuing Peter from an explosion, emanates a waning blue-violet glow in the dark, smoky shambles, as her fairy spirit drains away. Blair makes the moment both poignant and eerie.

Shapes in *Peter Pan* (leaves, trees, rocks, ships, tepees) more than ever resemble a collage. The look anticipates the actual cutouts Blair would use for It's A Small World a decade later.

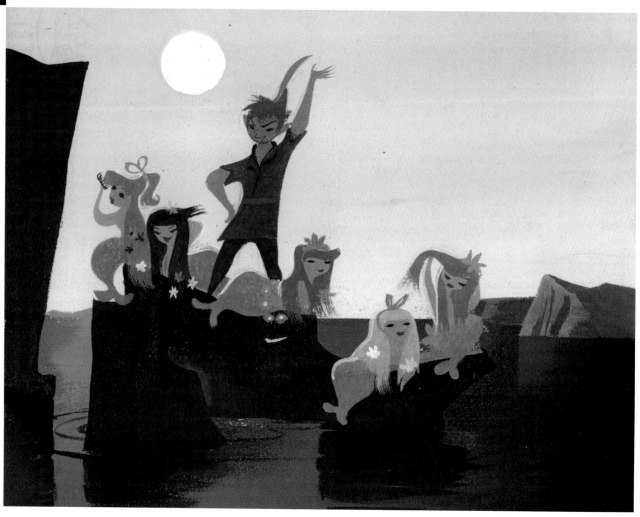

Top: A film frame of Mermaid Lagoon from Peter Pan.
Above: Blair's inspirational painting for the same sequence. Collection of Sue and Eric Goldberg.

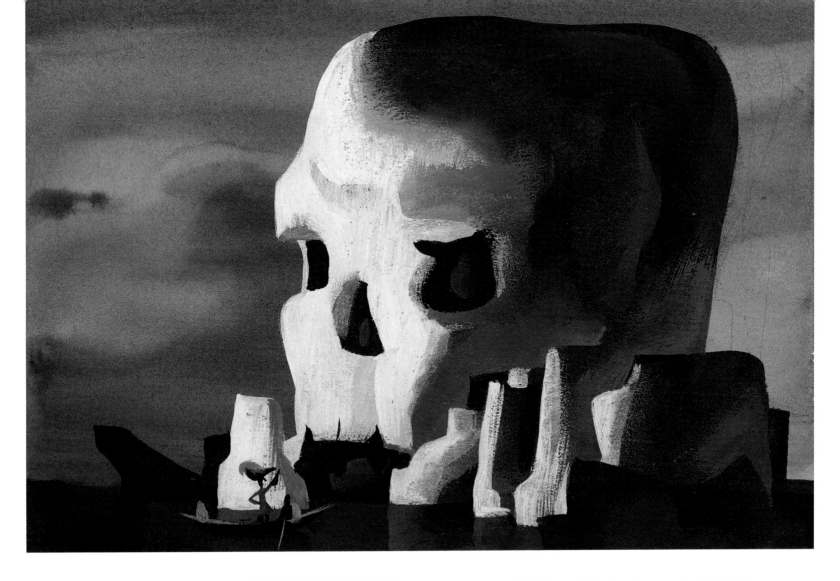

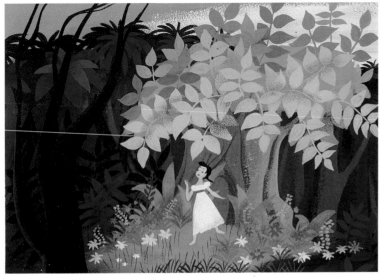

Contrasts in mood: Evil Captain Hook arrives at spooky Skull Rock, while Wendy frolics in a Botticelli forest.

Left: Collection of Pete Docter.

61

Disney saw *Cinderella*, *Alice*, and *Peter Pan* as stories about the comfort and protectiveness of the family unit, traditional values and sex roles, togetherness, love, and no-place-like-home sentiments. His films appealed to the dominant family-oriented postwar society, reassuring its sense of well-being in a post-Hiroshima, post-Holocaust world.

Mary Blair's fluidly organic shapes—at once primitive and futuristic in colorful, attractive imagery—subconsciously reinforced Disney's message, reaffirming life and its promise.

Below and opposite page, top and bottom: Blair's organic shapes, both primitive and futuristic, anticipate her collage art for It's A Small World. Courtesy of Howard and Paula Lowery.

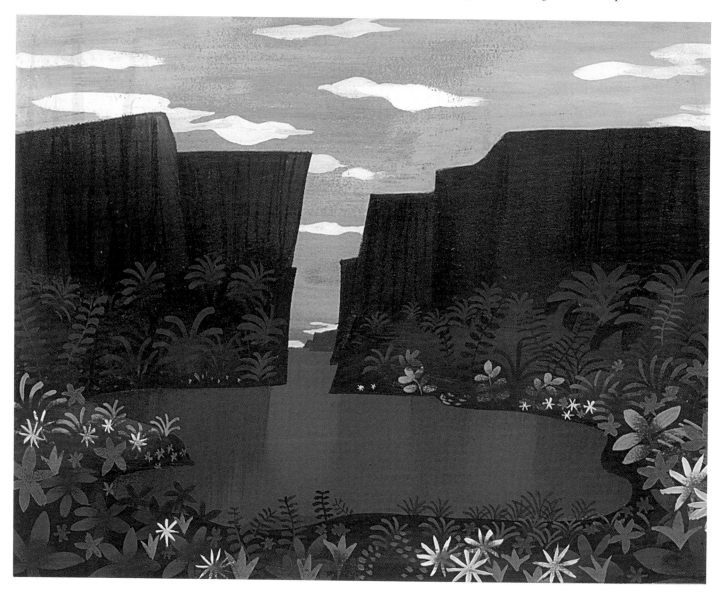

THE ART AND FLAIR OF MARY BLAIR

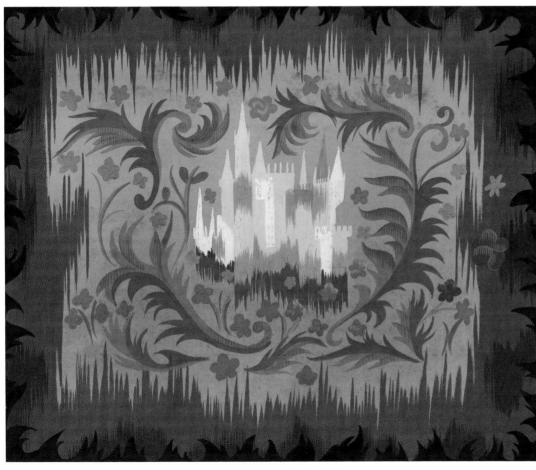

Left: Cinderella's dream castle painted to resemble a tapestry.

During a period of national nervousness about cold war power struggles and nuclear annihilation, "vital forms of organic derivation came to define the look of the era in 'high art' and in popular culture," writes historian Kevin L. Stayton, citing kidney-shaped coffee tables and swimming pools, boomerang-pattern Formica, fishtail cars, and daring gestural paintings.[17] These organic forms found their way into Disney's early 1950s cartoon features as well, via Mary Blair.

Freelancing

Or chocolate flavored milk

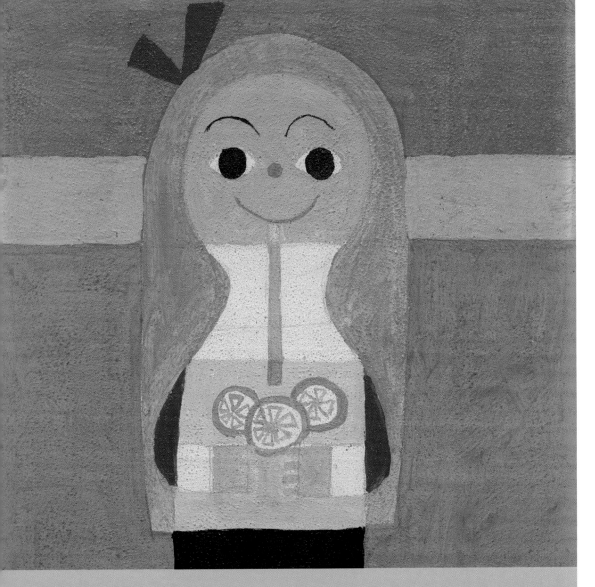

"Walt really loved working with Mary," says Marty Sklar, veteran Disney Imagineering executive. "I am sure it was not a happy moment when she went off to do her own thing."[1]

Family concerns may have led Mary Blair to resign from Disney in February 1953, just before *Peter Pan*'s release. Perhaps she wanted more time for her children, then ages six and three.

In any case, it was an amicable parting. Through the years afterward, many affectionate letters passed between Walt and Mary, and every Christmas a box of toys arrived for her sons.[2] "Walt Disney was one of the most wonderful men in the world," she said years later. "He was a family man."[3]

Perhaps she left the studio because it was unclear how she might be utilized in the future. Disney's next feature, *Lady and the Tramp*, was a project on which Blair had toiled more than a decade earlier.

Top: Mary Blair in 1950.
Above: A 1950s milk advertisement.
Left: Mary Blair's Lemonade Girl.

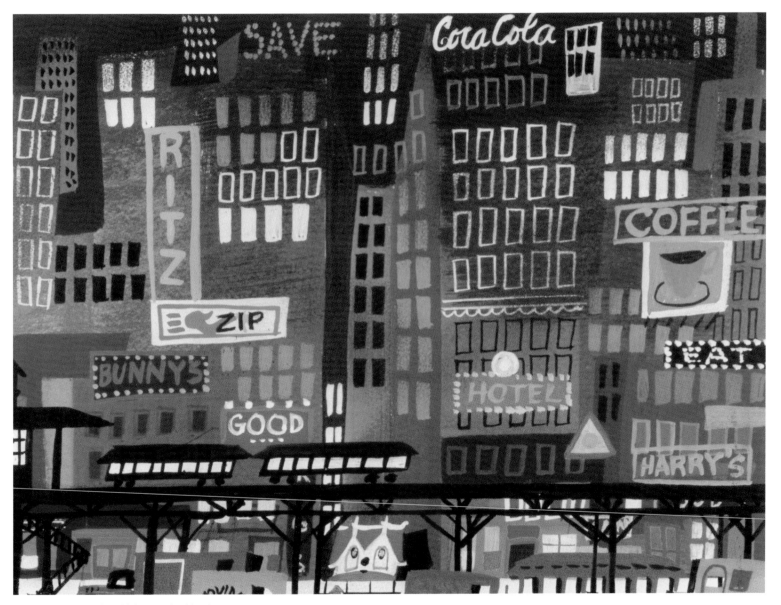

The Little House *(1952) lost in the big city.*

The star of Susie the Little Blue Coupe *(1952) woos a potential buyer from an auto showcase.*

In 1952, she art-directed—for the first time—two shorts, an indication the studio was trying to find projects for her. She did a fine job on *Susie the Little Blue Coupe* (released June 1952) and a spectacular one on *The Little House* (released August 1952), one of the handsomest shorts Disney ever produced.

The latter production, based on Virginia Lee Burton's beloved children's book, stuck closer to Mary's sketches than did the former (based on Bill Peet's original story and art). In *The Little House*, color blocks filled with graphic details perfectly capture bucolic countryside and cacophonous city. A grid of neon signs madly blinking in an urban scene has the rhythmic musicality and zip of Piet Mondrian's *Broadway Boogie-Woogie* of 1943.

THE ART AND FLAIR OF MARY BLAIR

Left and below: The Little House *by day and at night; contrasting hot and cool colors evoke an emotional response from the viewer.*

Additional The Little House concepts from the prolific Blair.

Top and below: A fiery scene from The Little House presents a dialogue between reality and abstraction. Courtesy of Howard and Paula Lowery.

Left and below: Blair uses Mondrian-like grids for a sense of aggressive urban modernity that leaves old-fashioned Little House *literally in the cold.*
Courtesy of Howard and Paula Lowery.

Right and below: Two of Mary Blair's distinctively styled holiday cards.

Far right: An advertising design for children's underwear.

Christmas Greetings

Blair's dynamic interaction of colors—the way foreground and background hues affect spatial perception; the multiple readings available from a single color depending on what color surrounds it—intuitively put into play theories of painter Josef Albers (1888–1976). Like Albers, Mary Blair often "worked straight from the tube," recalls Rolly Crump, her associate on It's A Small World. "I don't think she mixed paint very much. She used all and every color. That's the thing I learned from her: 'Don't be afraid of color, Rolly.'"[4]

"[T]he first day I came to work at Disney," wrote background artist Eyvind Earle, "up on the wall of one of the artists' rooms were about a hundred exquisite little paintings [for *The Little House*] by Mary Blair. It was her job to do the first original styling for a feature or special short. She was a great artist. A great designer and a great colorist. In my mind, I said to myself, 'That's the job I want at Disney.'"[5]

Mary Blair in her home/studio in Great Neck, New York in the 1950s.

Earle got his wish. He soon became *the* sole color stylist for the 1959 feature *Sleeping Beauty*. Earle found (as had Blair) resistance to his bold, decorative style, but this time Disney publicly defended the artist. At a meeting with recalcitrant animators and layout artists, he said,

> *For years and years I have been hiring artists like Mary Blair to design the styling of a feature, and by the time the picture is finished, there is hardly a trace of the original styling left. This time Eyvind Earle is styling* Sleeping Beauty*, and that's the way it's going to be.*[6]

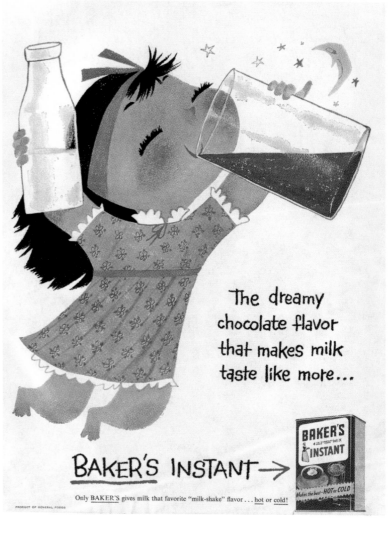

Disney sought a special look for this feature beyond the bland house style of *Lady and the Tramp*. But while Earle's work is as high style as Blair's, it lacks humor, whimsy, and any trace of warmth. It is interesting to speculate what Mary Blair might have brought to *Sleeping Beauty*.

"After Mary's withdrawal from Disney's," wrote *American Artist* magazine in 1958, "the printing press supplanted the cinema as the medium for the reproduction of her colorful art."[7] She continued illustrating children's books, a field she entered while still at Disney. *Baby's House*, which *The New York Times* of February 12, 1950, favorably reviewed ("catches the young child's satisfaction in everyday objects as Baby marches through the house"), is notable among her early books. *I Can Fly*, first printed in 1951, garnered a 1960 letter from Jacqueline Kennedy at the White House, claiming it a favorite book of daughter Caroline.[8]

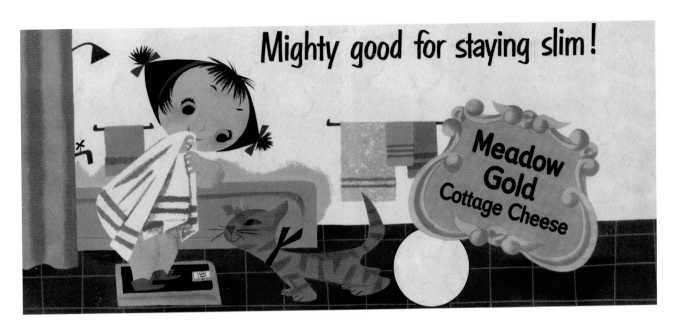

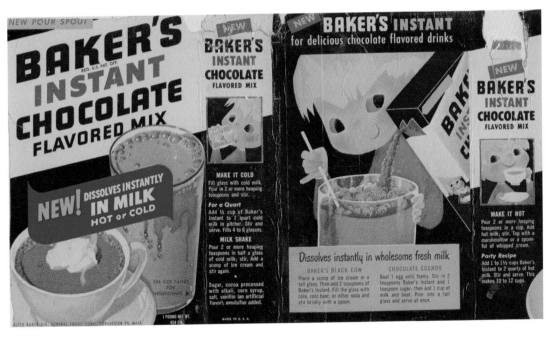

Above: The little girl design in Meadow Gold ads was based on the child in I Can Fly, *Blair's best-known children's book, first published in 1951.*

Left: Box design for Baker's Chocolate mix.

An *I Can Fly* illustration was used as a basis for a national advertisement and product design campaign for Meadow Gold Dairies. Variations on Blair's bigheaded toon kids appeared in magazine advertisements for Baker's Instant Cocoa, Blue Bell children's clothes, Nabisco, Johnson & Johnson, and Pepsodent television commercials.

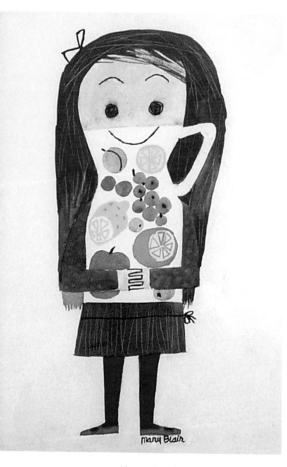

Above: Another variation on Blair's
Lemonade Girl amusingly substitutes a
pitcher's handle for the kid's ear.

Right: Variations on Blair's
Pall Mall ad designs.

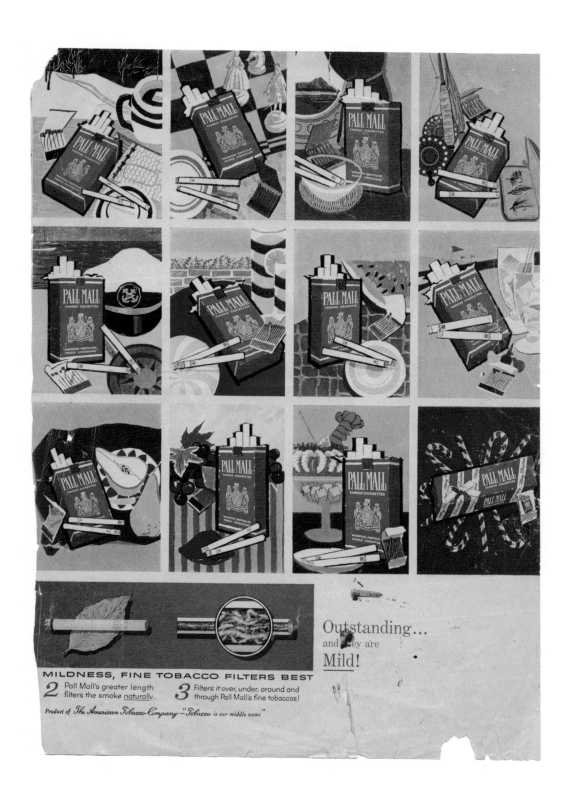

Blair designed twenty-four-sheet billboard posters for Maxwell House Coffee and Beatrice Foods, and two complete national campaigns for Pall Mall cigarettes. The latter painterly designs—a red cigarette pack outlined in thick black lines, alongside various fruits ("So friendly to your taste!")—were inspired by an ad agency art director, Blair said, "upon seeing a Picasso exhibition at the Museum of Modern Art."[9]

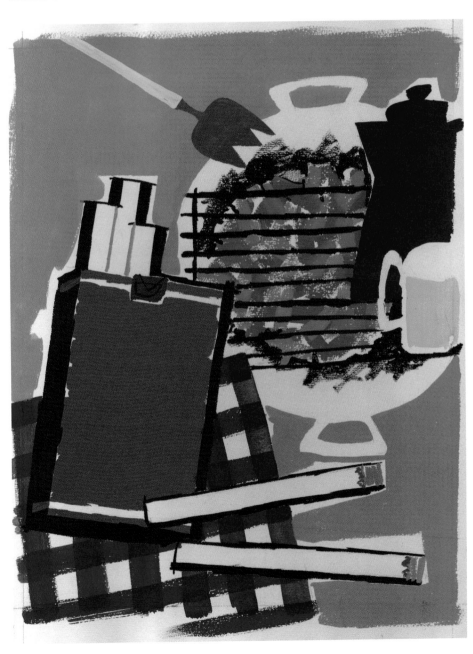

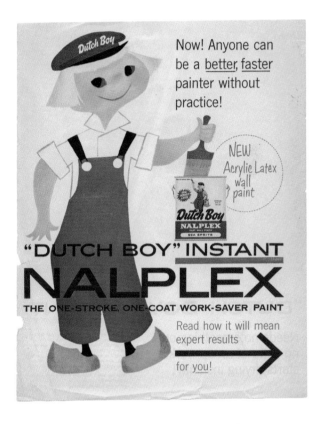

Left: Blair's basic design for a Pall Mall ad before typography was added.
Above: A Dutch Boy paint advertisement.

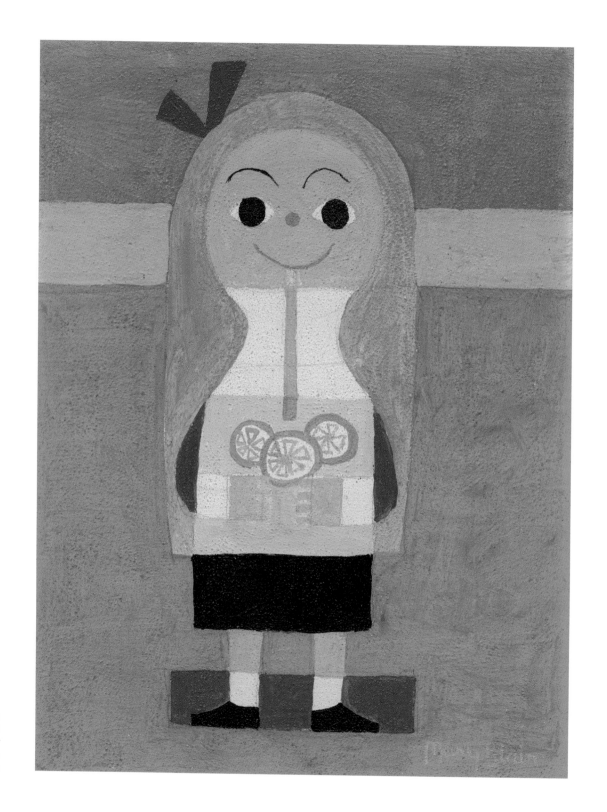

Blair's yummy Lemonade Girl plays with hot and cool colors, form, and time: the liquid refreshment's shape is both a pitcher and its final destination—a stomach. Collection of Alice Davis.

THE ART AND FLAIR OF MARY BLAIR

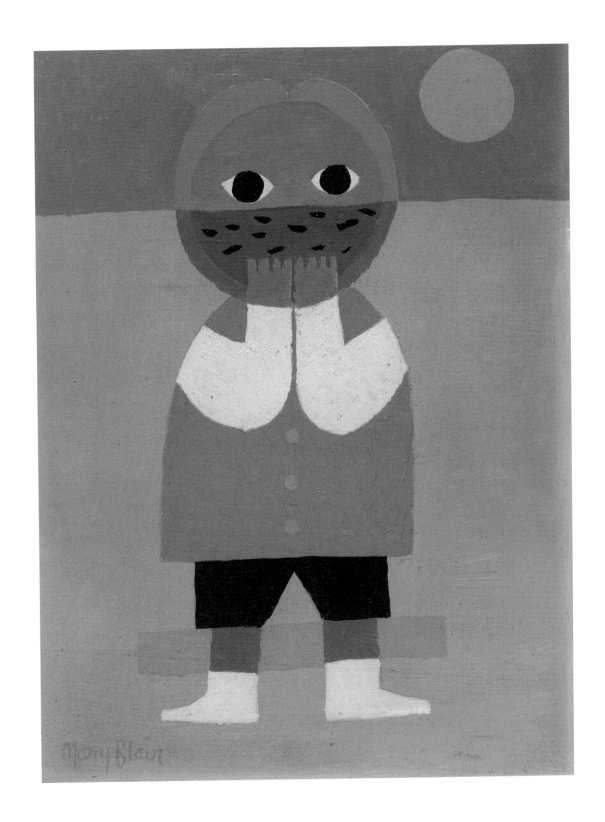

The smile of Watermelon Boy relates to the source of his joy—a cool fruit treat on a tropical day. Collection of Alice Davis.

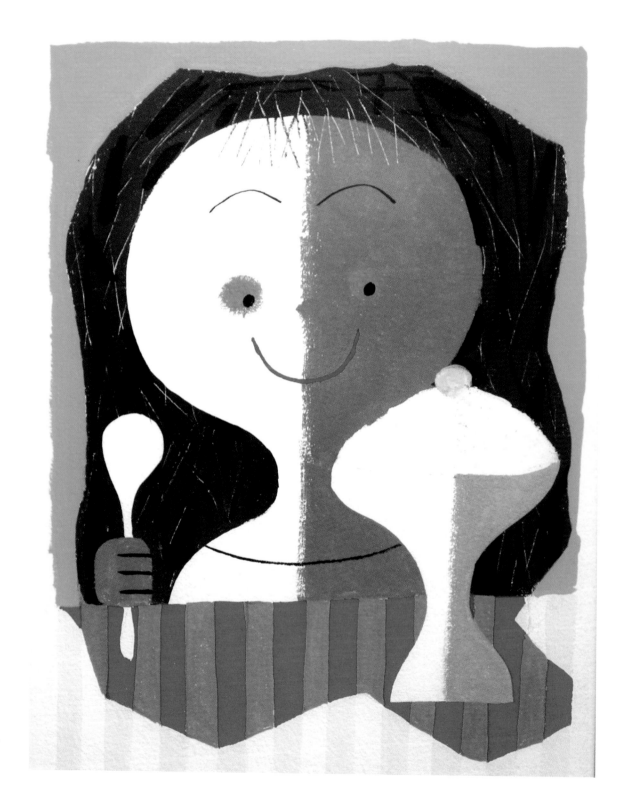

*"You are what you eat." Blair finds
fun in the similar shapes of a spoon,
a girl, and a sundae.*

THE ART AND FLAIR OF MARY BLAIR

Blair tentatively ventured into stage design during her freelance period, creating a number of Christmas and Easter sets for Leon Leonidoff extravaganzas at Radio City Music Hall.

More intriguing are set and costume designs conceived for *Cole Black and the Seven Dwarfs*, a never-produced Broadway musical with a Duke Ellington score. Book and lyrics for the Grimm/Disney parody were written in 1948 by T. (Thornton) Hee and William Cottrell, Disney storymen who were freelancing at the time.

A bedroom designed in 1955 by Mary Blair for Cole Black and the Seven Dwarfs, *a never-produced Duke Ellington Broadway musical. Collection of Dug Miller.*

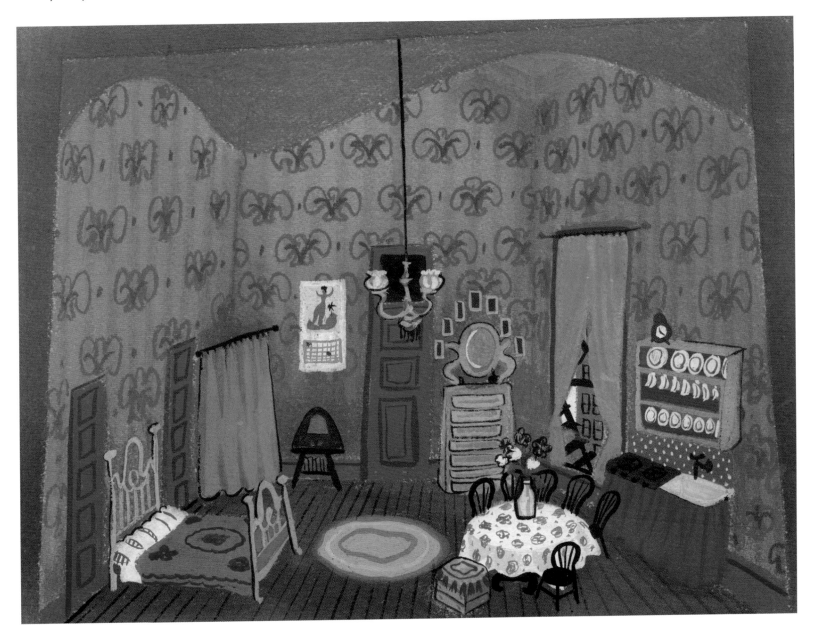

Brought into the project in 1955, Blair's vivid painterly scenery creates atmosphere with pure color. For "Queenie's Palace," Blair designed a seedy barroom in shades of green touched by hot pink. In "Voodoo Ballet," zombies with a single stripe running down their backs dance with an orange-haired witch who holds a bright red apple; the whole scene stands out with psychedelic electricity against a black void framed by olive green curtains. And the grand finale at a rooftop nightclub ("literally, a Castle in the Sky") is all neon, gold, and "festive" white, Blair's

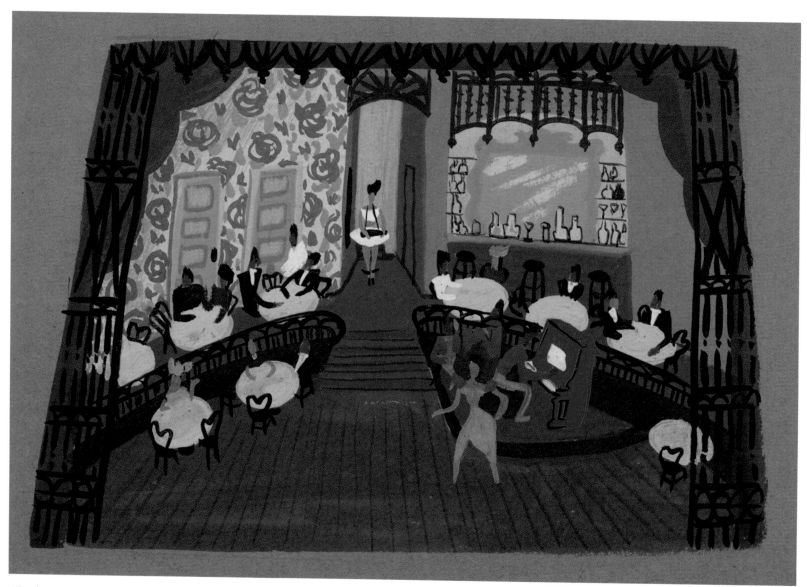

"Queenie's Palace," a saloon set, is the lair of the evil Queen in Cole Black and the Seven Dwarfs. *Collection of Dug Miller.*

THE ART AND FLAIR OF MARY BLAIR

ultimate joyous color choice.[10] "Not without reason is white taken as symbolizing joy and spotless purity," wrote Wassily Kandinsky in 1914.[11]

Blair's work resembles and precedes David Hockney's set and costume designs for opera. Hockney's stage work, which began in 1966, is (like Mary Blair's) "essentially posteresque," writes Martin Friedman in *Hockney Paints the Stage*—"depending more on painted illusion than actual volume, much of its dynamism was achieved through the interaction of light and color."[12]

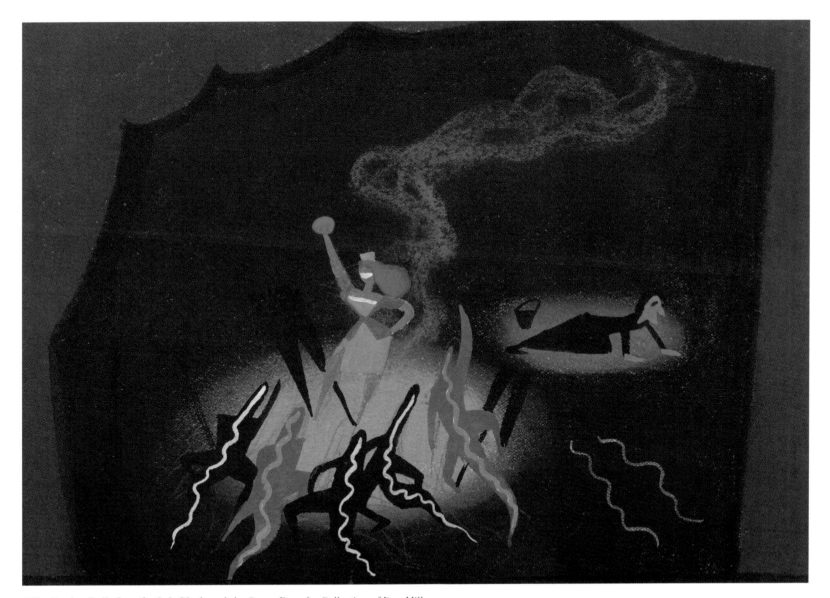

"The Voodoo Ballet" set for Cole Black and the Seven Dwarfs. *Collection of Dug Miller.*

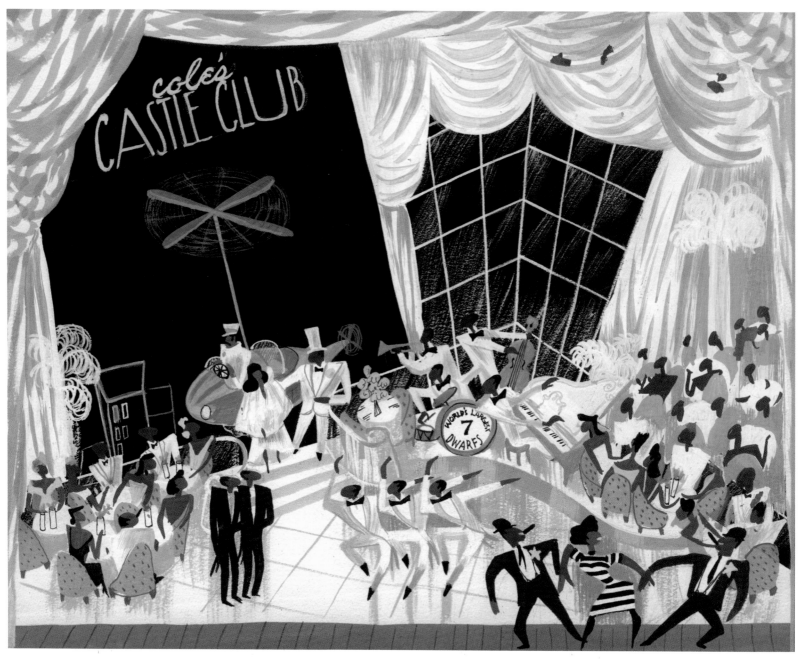

The grand finale of Cole Black and the Seven Dwarfs *takes place in a white-and-gold penthouse nightclub. Collection of Dug Miller.*

THE ART AND FLAIR OF MARY BLAIR

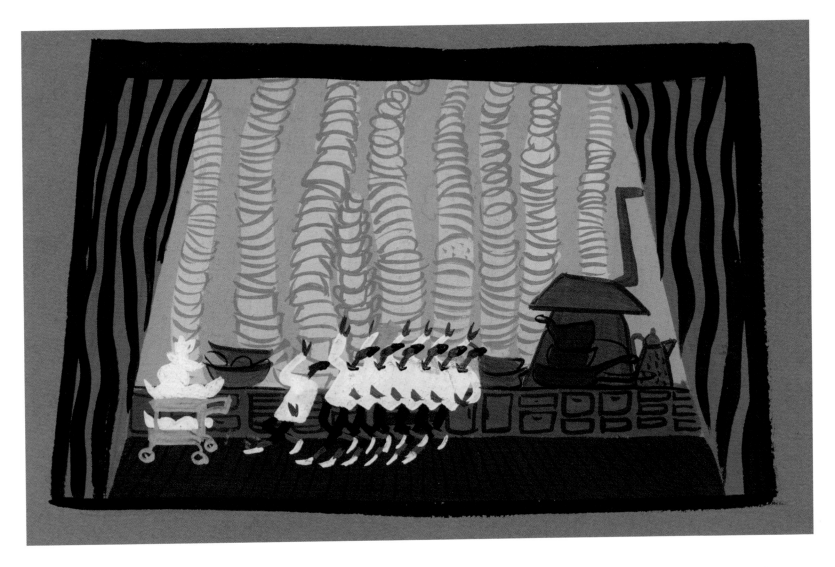

In April 1966, Blair met with Rudolf Bing, general manager of New York's Metropolitan Opera, to discuss Humperdinck's *Hansel and Gretel*. "I would love to design the opera," she wrote Walt Disney, who personally recommended her to Bing, "but the union rears its ugly head."[13]

It is a pity Mary Blair never expanded her art to Broadway and opera stages. However, in the 1960s and 1970s, Walt Disney provided her with three-dimensional, large-scale showcases that led her to new creative heights.

The seven dwarfs as waiters in a kitchen set from Cole Black and the Seven Dwarfs. *Collection of Dug Miller.*

Small World and Beyond

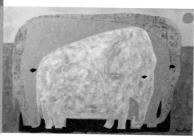

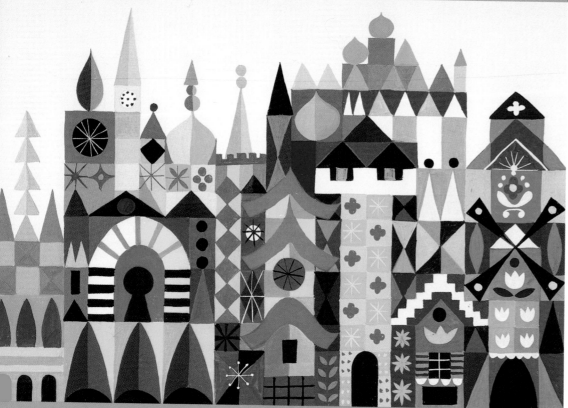

"We were doing the Audio-Animatronics figures for the World's Fair pavilions," recalls designer Rolly Crump, "and Walt came in and said, 'I've got an idea about this little boat ride about children around the world.' We looked at him like he was nuts!"[1]

"When we talked about what became It's A Small World," says Marty Sklar, "Walt remembered artwork of children made for *Saludos Amigos*. He said, 'We have to get Mary Blair to do it.' So he called her."[2]

"I think it hit her at the right time. It was a powerful package for her," says Crump. "It was about children, the freedom of color, and that Walt asked her to do it. Like she'd died and gone to heaven. Small World had to be the crescendo for her because I've never seen anything as powerful in her work. She just whipped this stuff out."[3]

Designing children from around the globe and their environments, Blair made

Top: Mary Blair in 1964.

Middle: Whimsical elephant shapes in a c. 1960s painting.

Bottom: Blair's 1963 suggestion for the exterior elevation of It's A Small World attraction.

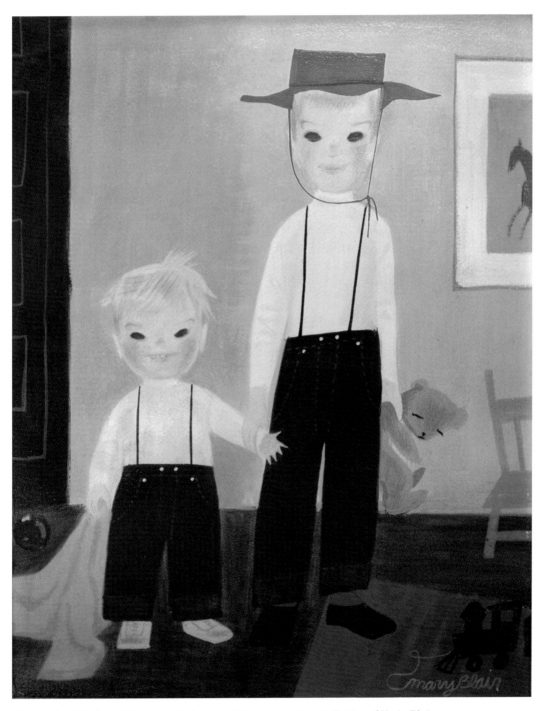

A portrait of Kevin and Donovan Blair painted by their mother. Collection of Kevin Blair.

dozens of intricately detailed collages. Her assemblages used wallpaper cuttings, cellophane (for a transparent effect), and acrylics, ingeniously combined in interlocking geometric and organic shapes. These dazzling constructions—breathtaking in their whimsical vitality and variety—contain her purest color combinations yet.

"Color is one of her best-cultivated senses," commented a review in a 1964 *Herald Tribune*:

> *She presents Asia in warm colors, Africa with a blue-and-green background,*
> *South America and Central America in pink, orange, and other vivid hues,*
> *and Europe in a variety of colors representing its many mixed nationalities.*
> *In the finale . . . she made white the dominant color. . . .*[4]

"I guess you could call it theater-in-the-round," Blair said of It's A Small World, but conceded, "it's really much more. The audience moves, the performers move, and everyone—especially the children—seem to have a grand time."[5]

A conceptual collage by Blair for the Pepsi Pavilion's It's A Small World at the 1964 New York World's Fair.

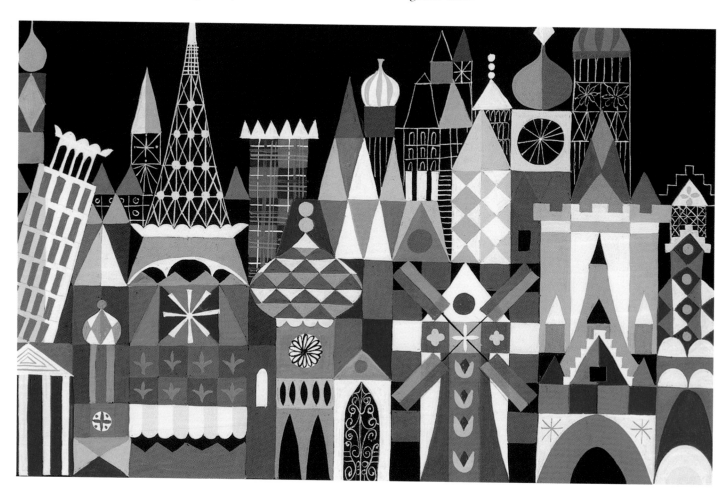

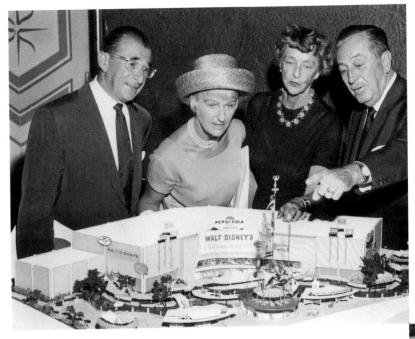

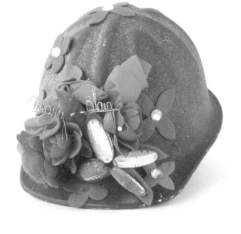

Right: Walt Disney (far right) and Mary Blair (in hat) look over a model of the Pepsi Pavilion in 1964.

Far right: Mary Blair's decorative hard hat worn during construction of It's A Small World.

The final 3-D ride, while charming and fun, lacks the concentrated visual power of Blair's original designs; in them, her joy communicates in an emotionally dimensional way that is extraordinary. "If those had been built the way she suggested," comments author Karal Ann Marling, "they would have looked more like Frank Lloyd Wright married to Andy Warhol."[6]

It's A Small World represents a new pinnacle in Mary Blair's career. After a decade of free-lance jobs that rarely challenged her—restrictive advertisements, mild children's books, and aborted stage productions—here was a project she deeply cared about, working for someone who always inspired her best work.

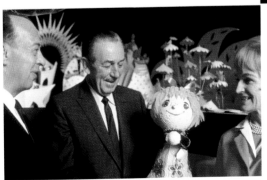

Above: Walt Disney and Mary Blair discuss her designs.

Left: Marc Davis, far left, and Walt Disney present Blair with a special It's A Small World "Mary Blair doll," a caricature of the artist.

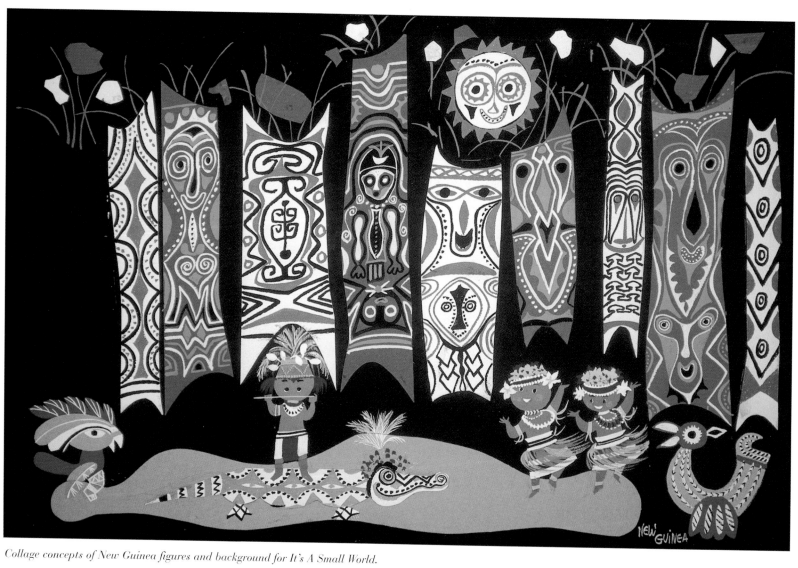

Collage concepts of New Guinea figures and background for It's A Small World.

THE ART AND FLAIR OF MARY BLAIR

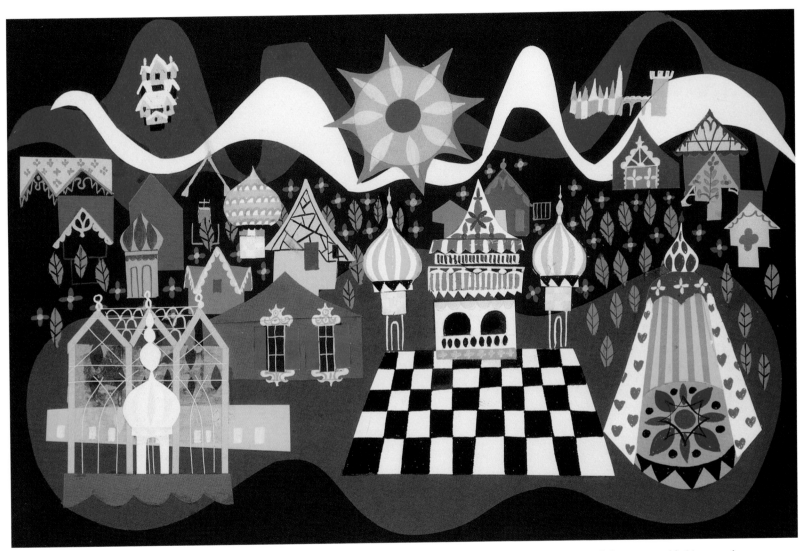

For Blair's vibrant collages, she used colored paper shapes, and even cellophane, pasted onto black backgrounds, with detailed patterns added in gouache.

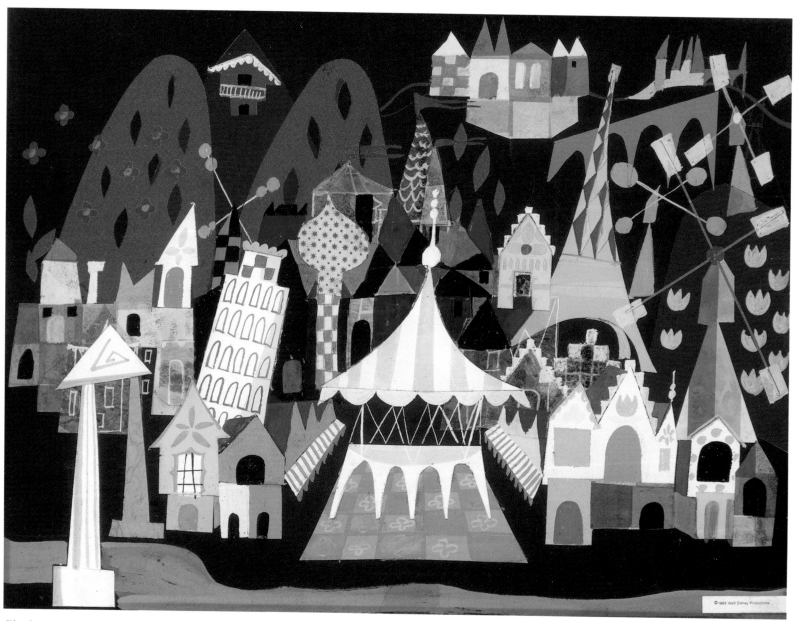

Blair's synthesis of world architecture in a single setting creates a sparkling composition, subtly promoting unity and harmony among different cultures.

THE ART AND FLAIR OF MARY BLAIR

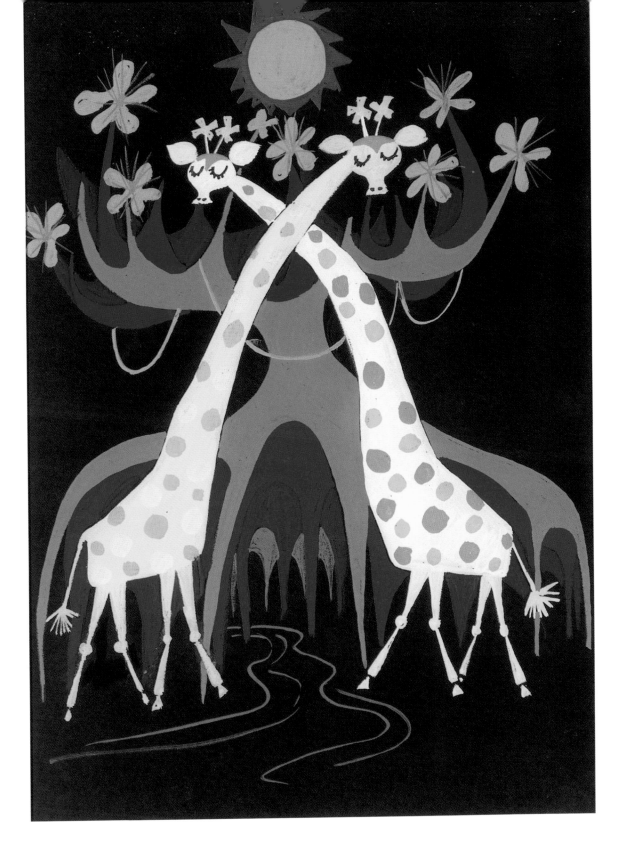

Two gentle giraffes form an arch through which the It's A Small World boats float.

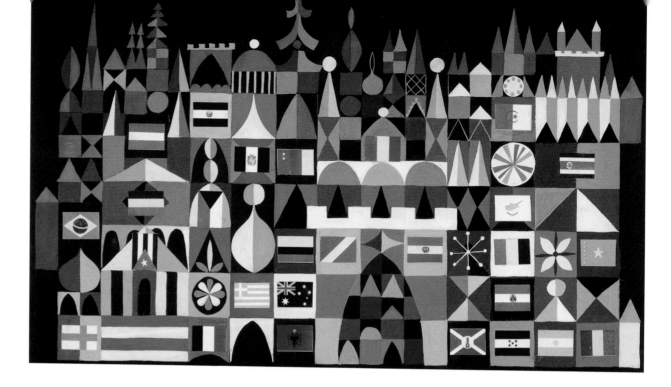

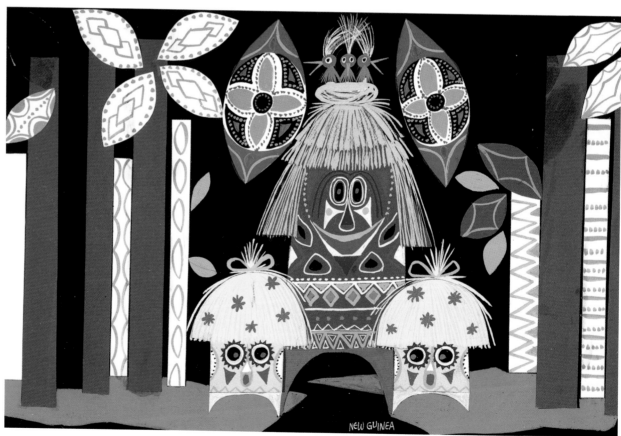

Top and bottom: In 1965, when It's A Small World moved from the New York World's Fair to Disneyland, Mary Blair created additional designs.

THE ART AND FLAIR OF MARY BLAIR

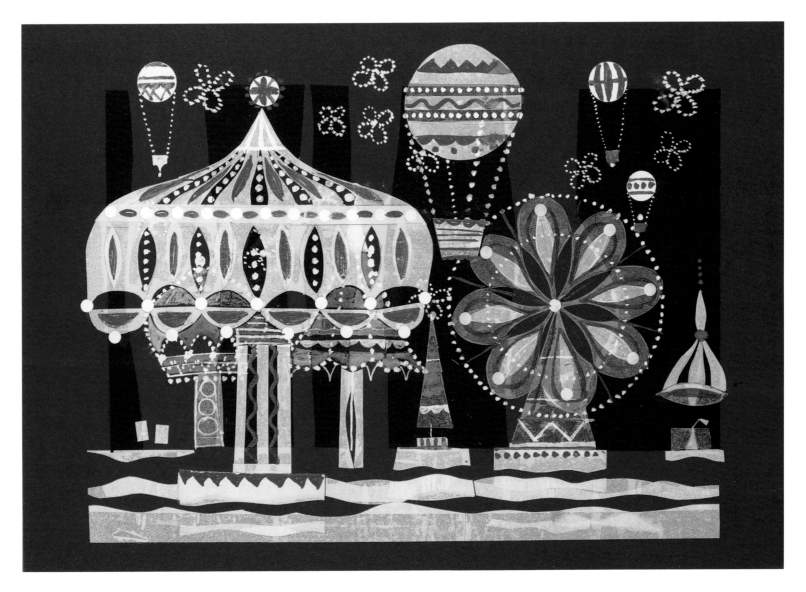

When It's A Small World moved to Disneyland in 1966, then to Walt Disney World in 1971, the prolific Blair contributed dozens more exquisite collages for building exteriors and new scenes.

Disney next ushered her into the world of fired clays and textural colors of transparent (almost fluorescent) purity. In November 1966, the $6 million Jules Stein Eye Institute opened at the UCLA Center for Health Sciences in Los Angeles. A unique feature in the children's wing of the outpatient clinic is a large 220-square-foot ceramic mural designed by Mary Blair.[7]

White, Blair's favorite "festive" color, dominates the show finale of It's A Small World.

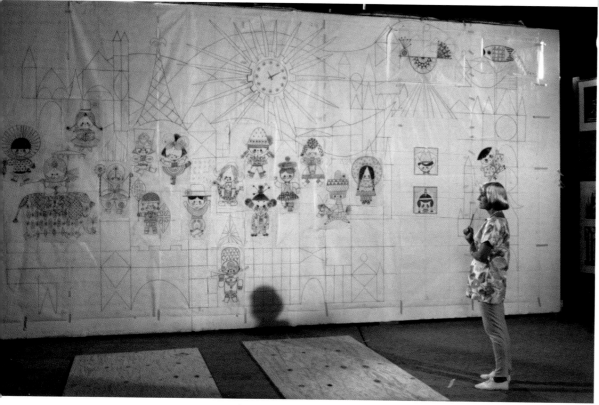

Above: Mary Blair at work on the UCLA/Stein Eye Institute mural.

Left: Blair contemplates the mural's 220-square-foot template.

The mural's tiles feature charming international cartoon kids positioned around a real clock and examining-room door. It offers a playful welcome to real children entering a traditionally sterile (and scary) hospital environment.[8]

The projects got bigger. At Disneyland in 1967, the Tomorrowland section unveiled two striking Mary Blair artworks. Facing each other on the Inner Space building and the Circle-Vision building, they formed a 54-foot-long and 15½-foot-high "corridor of murals."

In one mural, children from different nations play beneath hovering communications satellites. Colorful ribbons connect various areas symbolizing communication ties between countries, again making ours a "small world." In the other mural, "Energy" is depicted today and in the future.

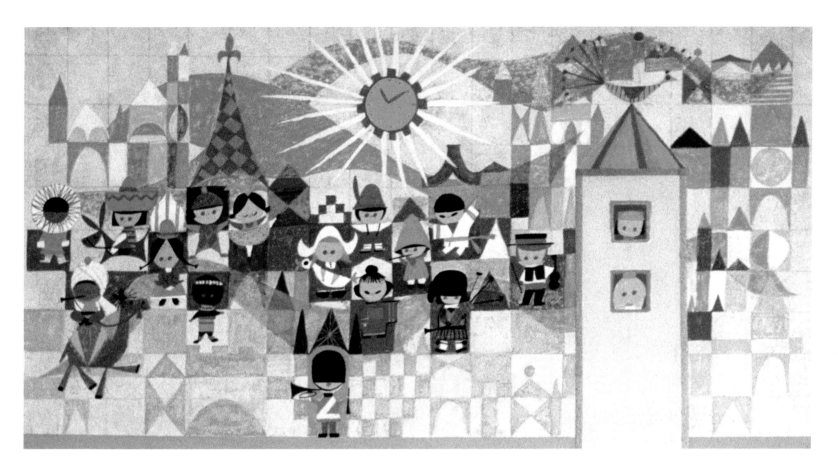

Above: The completed mural, November 1966.
Left: Mary Blair and WED colleagues.

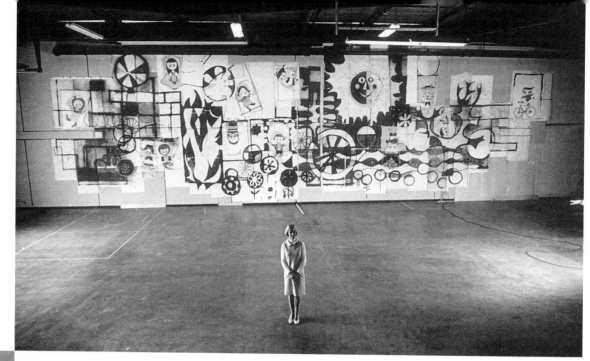

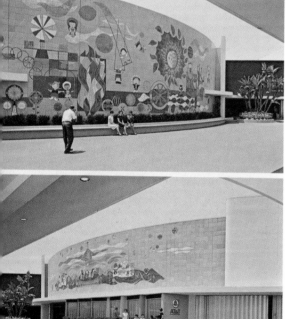

Right: Blair in front of her Tomorrowland mural.
Below: Blair's futuristic ceramic designs formed an entrance corridor for the Tomorrowland area of Disneyland.

Here is an example of Walt Disney's thinking of Mary Blair's art as futuristic as well as evocative of the past. Again, Blair reinforces Disney's philosophy—in this case, reassuring the public regarding

> *Tomorrow [which] offers new frontiers in science, adventure, and ideals: the atomic age, the challenge of outer space, and the hope for a peaceful and unified world.*[9]

She became enamored with the ceramic-tile processes, likening it, she said, to "wet watercolors with their richness and glistening qualities. The effect is permanent, of course, because the ceramic tiles will not fade."[10]

The Tomorrowland murals were not truly permanent: both "disappeared" when they were covered over by renovations in 1987 and 1998. "Mary Blair's murals were not damaged or painted on," Marty Sklar notes, "but the decision was made for cost reasons to leave them in place—hidden treasures at Disneyland!"[11]

The third and last of the large-scale Blair ceramic murals appear on ninety-foot elevator shafts in the Contemporary Resort at Walt Disney World. The architect's original plan to encase them in shiny metal was superseded by Blair's warm tiles depicting little Indian figures in colors and designs abstracted from the Grand Canyon.

The artist recalled seeing "the finished tiles laid out on large tables in sections" before being fired in giant kilns. But it didn't prepare her for the huge final version at Walt Disney World's opening in Florida in 1971. "I walked into that giant concourse," she said. "My reaction was, 'Oh, wow!'"[12]

THE ART AND FLAIR OF MARY BLAIR

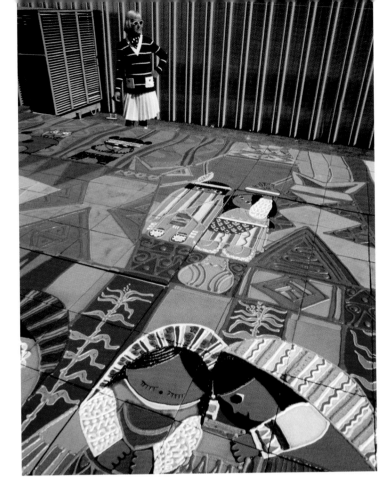

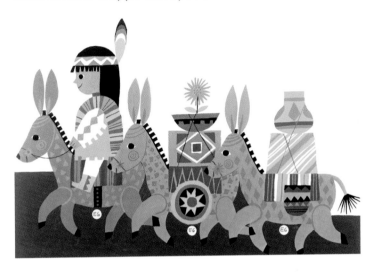

Left: Mary a-go-go! Dressed in 1970s mod, Blair oversees ceramic tiles for the Contemporary Resort at Walt Disney World.

Below: Character study for Contemporary Resort.

During the 1960s, Mary Blair, then in her fifties and coiffed in a blond pageboy, maintained a distinctive personal stylishness. She alternated between chic Oleg Cassini-ish, softly tailored pastel suits resembling fashions made for Jackie Kennedy, and futuristic Rudi Gernreich-like miniskirts, bold geometric patterns, and shiny go-go boots.

To all outward appearances, the affluent Blair family enjoyed a life straight out of a *Saturday Evening Post* cover. Neil A. Grauer, childhood friend of the Blair boys, remembers

> *innumerable, wonderful sailing trips on the Blairs' boat on Manhasset Bay and Long Island Sound [with] great barbecues on board . . . swimming, being pulled on a rope through the water as the sailboat raced along. These were grand occasions. In the winter . . . ice skating on the Old Mill Pond that lapped the shores of their property on Beach Road in Kings Point . . . Mary would have hot chocolate and sandwiches for us back at the house. [Also] very festive Christmas gatherings to trim the Blairs' tree, which was always quite large. Mary popped corn, and we'd string the popcorn for decoration, as well as hang all sorts of ornaments, including red silk apples. . . . [E]very Christmas a box of the latest Disney games and toys arrived for Donovan and Kevin, directly from Walt.*[13]

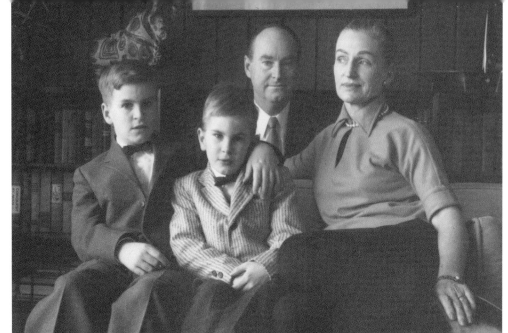

Right: The Blair family of Great Neck, c. 1958.
Below: Kevin and Dorovan Blair, a painting by Mary Blair. Collection of Kevin Blair.

But by 1970, personal problems led to the sale of the Great Neck house and Lee's business, and to the family's moving to Soquel in northern California. The reasons require a fuller discussion than is possible in this volume. But a root source of the problems was Lee's and Mary's alcoholism, which was hereditary in both families.[14]

By the 1960s, their lifelong fondness for drink had become a full-blown addiction. Lee, though a successful TV commercial producer, was frustrated and angry that business consumed his time, and he painted infrequently. He held a long-simmering jealousy of Mary's success at Disney, which was reopened like an old wound by the 1964 World's Fair and his wife's subsequent commissions. Also, both Mary and Lee shared a guilt regarding their youthful goal to become fine artists, a dream abandoned for financial security.

A major toll was taken by their eldest son's emotional difficulties and subsequent hospitalization on the East and West coasts. "I remember Mary saying to me," says Alice Davis, "the first week he was in the hospital, it cost them $30,000 and they had no health insurance. Straight out of their pocket."[15]

Until Lee joined Alcoholics Anonymous in the mid-1970s, he was usually drunk by noon and verbally and physically abusive until collapsing (more than once into the evening meal).[16] Mary, a quiet imbiber, was proud of her ability to consume multiple martinis at lunch and dinner without apparent outward effect on her ability to work.

She was what Caroline Knapp called a "high-functioning alcoholic." Knapp, an award-winning writer and columnist, wrote about concealing the effects of alcohol in her own life:

> . . . *Smooth and ordered on the outside; roiling and chaotic and desperately secretive underneath, but not noticeably so, never noticeably so.*[17]

THE ART AND FLAIR OF MARY BLAIR

Three paintings of the Blair boys by their mother. Collection of Kevin Blair.

Eventually, people noticed. Alice Davis was the first to observe "that Mary's color had gone to mud." A San Francisco art agent abruptly dismissed Mary's work as "old-fashioned," when it was apparent that her ability to perform had become severely diminished.[18]

The beginning of her reversal of luck could really be said to have begun with Walt Disney's death in December 1966, which devastated Mary. "She was destroyed," said children's book illustrator Gyo Fujikawa. "So sad and unhappy. She wept."[19]

Mary sorely missed Walt, her friend and benefactor, both personally and professionally. When the projects he set up for her before his death were finished, she was never again hired by Walt Disney Imagineering.

Her last professional credit was shared with Lee for slide-show illustrations for a San Francisco Symphony Orchestra concert of Ravel's *L'Enfant et les Sortilèges* in 1974. But it is obvious that Lee did all the drawings.

Gradually, Mary withdrew to watch television and drink all day. In 1975, Lee wrote to relatives that she was recovering from "the desperate stages of withdrawal and, believe me, it is hard to see someone you love in that condition."[20]

"She had alcoholic dementia," says niece Maggie Richardson. "She lost her memory. You can't drink for that many years and not have some real effects."[21]

Occasionally, Mary worked on a strange series of what she called "semidimensional paintings which are part painting and part constructions." *Le Chat*, a self-portrait, is garishly colored, mixing innocence with mild eroticism, and has an *art brut* feel. But it is barely recognizable as a work by Mary Blair.

"When there are enough of them, I will have an exhibition possibly in San Francisco," she wrote in a 1977 letter.[22] On July 26, 1978, she died of a cerebral hemorrhage. Lee scattered her ashes from a sailboat into the Pacific.

Mary Blair had chronically poor eyesight. "She always had a purseful of eyeglasses," recalls Alice Davis. "Sometimes she would have on two pair of glasses plus contact lenses to see something. I said to her, 'God, that's why you're so great with color. We have to stand back and squint our eyes to see how colors work together, and you have that naturally.' We always giggled about that."[23]

Blair's ability as a master colorist and designer sprang from within. "That is beautiful which is produced by the inner need, which springs from the soul," as Wassily Kandinsky wrote.[24] She was an intuitive artist, who trusted her "inner self," which Arthur Wesley Dow described as the place where the essence of art lay in creative design.[25]

The general public's knowledge of Mary Blair's name and her art is limited. Only one of her children's books is still in print, and the hundreds of conceptual paintings she made for ani-

Interlocking elephants showcase Blair's appealing expressionism, humor, and bold use of nonrealistic color.

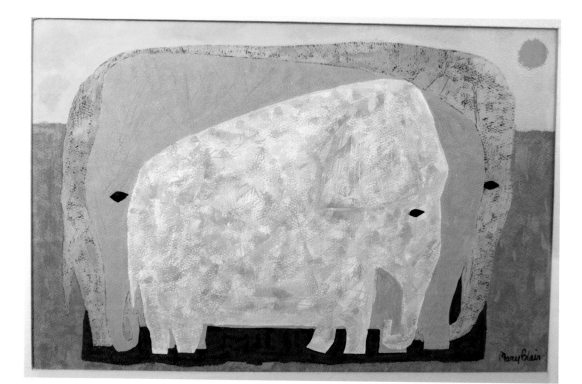

Left: One of Mary Blair's last works: a "semidimensional" painted construction. Below: Mary Blair, 1977.

mated films are stored at the Disney studio or are in private collections. (Among the cartoon cognoscenti, Blair's artworks are highly collectible.)

Her vibrant original designs were "adapted" for Disney films and theme parks. Yet her influence is wide—particularly, her remarkable use of color which became an integral part of the Disney canon. Disney color, in turn, was an influence on a number of Pop artists, including Peter Max, Keith Haring, and Andy Warhol, who each had an "avidity for the products of popular culture."[26]

As can be seen in this volume, Mary Blair and her art deserve greater renown; her ultimate gift—bringing instantaneous pleasure and delight to the viewer—is rare in any age and eternally welcome.

In the animation world, she continues to inspire new generations of designers, including computer artists. Concept art for the Pixar feature *Monsters, Inc.* (2001), for example, "does bear Mary Blair's influence," notes Pete Docter, the film's director. "Her work is such a treasure trove of riches in terms of focusing the eye and drawing you in. She has a way of framing things, giving it a vignette sort of a feel.

"In every production, there's a phase where we say, 'Let's look at Mary Blair stuff!'"[27]

Notes

Mary's World

1. "Fair's 1st Day: Jail 294, Stall-In Fails," *New York Daily News*, April 23, 1964.

2. "Fun in New York," *Time*, May 1, 1964, pp. 40–41.

3. "Power Snafu Does Ditto for Disney & Two Other Shows," *Variety*, April 22, 1964; Christopher Finch, *The Art of Walt Disney* (New York: Harry N. Abrams, 1995), p. 420.

4. It's A Small World continues to delight audiences at Disneyland and Walt Disney World.

5. *Newark News*, n.d., Walt Disney Archives (WDA); *Walt Disney's It's A Small World—Complete Souvenir Guide and Behind the Scenes Story*, Walt Disney Imagineering (WDI) Archives. Martin A. Sklar, currently vice chairman and principal creative executive of WDI, anonymously wrote the Souvenir Guide in 1964.

6. Neil A. Grauer to author, May 8, 2002; Gene Gleason, "About People—Designer," *The New York Herald Tribune*, August 2, 1964. Imagineer Joyce Carlson says that Blair wore colored contact lenses to "match her outfits." Jim Korkis to author, August 21, 2002.

7. "About People—Designer."

8. Answers to questionnaire from *Mademoiselle* magazine, ca. 1944. Unpublished. WDA.

9. Ollie Johnston to author, January 7, 1995.

10. Karal Ann Marling to author, January 14, 2002.

11. Rolly Crump to author, January 5, 1995.

12. Steven Watts. *The Magic Kingdom* (Boston, New York: Houghton Mifflin Company, 1997), p. xvi.

13. Ibid.

14. Brooke Kamin Rapaport and Kevin L. Stayton. *Vital Forms: American Art and Design in the Atomic Age, 1940–1960* (New York: Harry N. Abrams, 2001), p. 25.

15. Marling interview.

16. Joe Grant, as of winter 2003, continues to work as a story and concept artist at the Disney studio at the remarkable age of ninety-four.

17. Wendy Wick Reaves. *Celebrity Caricature in America* (New Haven/London: Yale University Press, 1998), pp. 10, 12.

18. Michael Giaimo to author, March 21, 2002.

19. Barbara Burklo, "Soquel Artist Proves 'It's A Small World,'" *Santa Cruz Sentinel*, July 25, 1971.

20. Carol Hymowitz, "In the Lead": "Women Plotting Mix of Work and Family Won't Find Perfect Plan." *The Wall Street Journal*, June 11, 2002.

Watercolor Days

1. Maggie Richardson to author, March 17, 2002.

2. Jeanne Chamberlain to author, May 9, 2002.

3. Alice Davis to author, June 11, 2002.

4. Ibid.

5. Robert Perine. Chouinard: *An Art Vision Betrayed* (Encintas, Calif.: Atra Publishing, 1985), p. 46; see also www.illustration-house.com/bios/carter_bio.html

6. Answers to questionnaire from *Mademoiselle* magazine, ca. 1944. Unpublished. WDA.

7. Robert Perine, p. 69.

8. Susan M. Anderson, "California Watercolors 1929–1945," *American Artist*, August 1988, p. 48.

9. Gordon T. McClelland and Jay T. Last. *The California Style* (Beverly Hills: Hillcrest, 1985), pp. 7, 9.

10. Arthur Millier, *Los Angeles Times* clipping, dated April 1938.

11. Susan Anderson, p. 51.

12. "Practical Values of Art," *The Western Woman*, vol. IX, #9, April/May/June 1938, pp. 18–19.

13. Lee Blair to Robin Allan, June 8, 1985.

14. Dale Pollock, "They Animated 'Fantasia,'" *Santa Cruz Sentinel*, June 20, 1976.

15. Ibid.

16. Lee Blair to Michael Barrier, October 25, 1976.

17. *Mademoiselle* questionnaire.

18 Ibid.

South of the Border

1. Charles Solomon. *The Disney That Never Was* (New York: Hyperion, 1995), p. 169.

2. Answers to questionnaire from *Mademoiselle* magazine, ca. 1944. Unpublished. WDA.

3. Lee Blair to Robin Allan, June 8, 1985.

4. *Mademoiselle* questionnaire.

5. John Canemaker. *Before the Animation Begins: The Art and Lives of Disney Inspirational Sketch Artists* (New York: Hyperion, 1996), p. 126.

6. Mary Blair to Ross Care, February 18, 1977.

7. Ibid.

8. Fred Cline to author, May 9, 2002.

9. Mary Blair to Ross Care.

Surprise Packages

1. Disney Inter-Office Communication, November 29, 1943. WDA.

2. Bureau of Naval personnel questionnaire. Courtesy Kevin Blair.

3. *The Architectural Forum*, March 1940; *House Beautiful*, October 1946, pp. 165–168.

4. Inter-Office Communication. "Mary Blair." November 29, 1943. WDA.

5. Richard Shale. *Donald Duck Joins Up* (Ann Arbor: UMI Research Press, 1982, 1976), p. 24.

6. Bob Thomas. *Walt Disney: An American Original* (New York: Simon and Schuster 1976), p. 204.

7. Frank Thomas to author, April 24, 2002.

8. Inter-Office Communication. "Mary Blair Itinerary." August 23, 1944. WDA.

9. Leonard Maltin. *The Disney Films* (New York: Crown Publishers, 1984), p. 101.

10. Mary Blair, letter to Walt Disney, April 20, 1945. WDA.

11. Maltin, p. 89.

12. Courtesy WDA.

13. Otto Kallir. *Grandma Moses* (New York: Harrison House/Harry N. Abrams, 1984), p. 30.

The Big Three:
Cinderella, Alice & Peter

1. Lee Blair, letter to Walt Disney, November 25, 1945. Courtesy Kevin Blair; Walt Disney, letter to Lee Blair, December 4, 1945. WDA.

2. Marc Davis to author, October 9, 1994.

3. Neil A. Grauer to author, October 30, 1994.

4. Lee Blair to Nancy Moure, April 13, 1991.

5. Alice Davis to author, June 11, 2002.

6. Mary Blair to Ross Care, February 18, 1977.

7. Ibid.

8. Michael Giaimo to author, March 21, 2002.

9. Frank Thomas to author, January 7, 1995.

10. Ibid.

11. Marc Davis interview by author, October 9, 1994.

12. Ward Kimball phone interview by author, October 13, 1994.

13. Mary Blair to Ross Care.

14. Ward Kimball to author.

15. *Before the Animation Begins*, p.186.

16. Joe Grant, oral history 2001. Interview by Charles Solomon.

17. Brooke Kamin Rapaport and Kevin L. Stayton, op. cit.

Freelancing

1. Marty Sklar to author, June 10, 2002.

2. Walt Disney, letter to Mary Blair, December 15, 1953:

> Dear Mary—Now that you have divorced yourself from Disney and have become a free-lancer, I'm only going to send you a card for Christmas—but the children, that's different—a box of things have been sent to them. All of us are very happy for you and we just want you and Lee to have all kinds of success which you both so rightly deserve. In the meantime, if you ever have any time on your hands, please let us know about it. . . .

3. Barbara Burklo, "Soquel Artist Proves 'It's A Small World'," *Santa Cruz Sentinel*, July 25, 1971.

4. Rolly Crump to author, January 5, 1995.

5. Eyvind Earle. *Horizon Bound on a Bicycle* (Los Angeles: Earle and Bane, 1990), p. 232.

6. Ibid, p. 239.

7. Ernest W. Watson, "Mary Blair." *American Artist*, May 1958.

8. Letter from Jacqueline Kennedy, dated December 9, 1960. Courtesy Kevin Blair. Among her other books are *The Golden Book of Little Verses* (1953) and *The New Golden Song Book* (1955); covers for *Walt Disney's Surprise Package* (1944); two different covers for *Walt Disney's Uncle Remus Stories* (1946 and 1974).

9. Mary Blair to Ross Care, February 18, 1977. The only public statement Blair ever made connecting her work to modern art.

10. The author is grateful to Dug Miller for allowing publication of Cole Black material.

11. Wassily Kandinsky. *Concerning the Spiritual in Art* (New York: Dover Publications, 1977), p. 39.

12. Martin Friedman. *Hockney Paints the Stage* (New York: Abbeville Press, 1983), p. 207.

13. Mary Blair, letter to Walt Disney, April 12, 1966. WDA.

Small World and Beyond

1. Roland Crump to author, January 5, 1995.

2. Marty Sklar to author, June 10, 2002.

3. Crump interview.

4. Gene Gleason, "About People-Designer." *Herald Tribune*, August 2, 1964.

5. Ibid.

6. Karal Ann Marling to author, January 14, 2002.

7. "UCLA Eye Institute Opens." *Los Angeles Herald Examiner*, November 3, 1966.

8. A newspaper clipping, ca. 1950 (probably from the *Los Angeles Times*) shows Blair in the new Beverly Hills Hotel Rodeo Room where she "evinced much interest" in glass tiles designed by Paul Lazlo.

9. "Profile—The 'Communications' Mural." Public relations sheet. WDA.

10. Ibid.

11. Marty Sklar to author, January 3, 2002.

12. Mary Blair to Ross Care, February 18, 1977. Blair painted a five-legged goat on one tile in keeping with Navajo tradition in which a flaw is deliberately incorporated into human crafts in deference to the perfection of the Divine.

13. Neil A. Grauer, "Mary Blair Remembrances," e-mail to author, July 12, 2002.

14. Ironically, Lee was related on his mother's side to the saloon-shattering Carrie Nation.

15. Donovan Blair describes his illness as "a nervous breakdown." Donovan Blair to author, June 6, 2002. Jeanne Chamberlain says he is "schizophrenic." Jeanne Chamberlain to author, May 9, 2002; Alice Davis to author, June 11, 2002.

16. Roland Crump to author, January 5, 1995; Maggie Richardson to author, March 17, 2002; John Hench to author, June 10, 2002; Kevin Blair to author August 19, 1994; Neil Grauer to author, October 30, 1994.

17. Caroline Knapp. *Drinking: A Love Story* (New York: The Dial Press, 1996), p. 12.

18. Alice Davis to author, October 9, 1994.

19. Gyo Fujikawa to author, October 27, 1994.

20. Lee Blair undated letter circa 1975 to Peggy and Frank Richardson, courtesy Jeanne Chamberlain.

21. Maggie Richardson to author, March 17, 2002.

22. Mary Blair to Ross Care, February 18, 1977.

23. Alice Davis to author.

24. Wassily Kandinsky, op. cit., p. 55.

25. Eric de Chassey. *American Art* (New York: Harry N. Abrams, 2002), p. 37.

26. Bruce D. Kurtz. *Keith Haring, Andy Warhol, and Walt Disney* (Munich: Prestel-Verlag, 1992), p. 13.

27. Pete Docter to author, March 15, 2002.

Chronology

1911

Born October 21, Mary Browne Robinson in McAlester, Oklahoma. Fraternal twin to sister Augusta ("Gussie"); sister Margaret born November 27, 1908. Daughter of John Donovan Robinson and Varda Morton Valliant married March 3, 1908. John (b. April 30, 1878, Easton, Maryland) listed "office work/bookkeeper" as occupation. Varda (b. August 22, 1888, Platte City, Missouri) was "housewife/seamstress."

Ca. 1913

Moves with family to Texas.

Ca. 1918

Moves with family to Morgan Hill, California (ten miles from San Jose).

John is caretaker of the Friendly Inn in Morgan Hill; family lives on third floor.

1925

Graduates from the Morgan Hill Elementary School.

1929

Graduates from Live Oak Union High School, Morgan Hill.

1929–1931

San Jose State College. Majors in fine arts.

Exhibits at seventh annual convention of the Pacific Art Association, Fresno.

Paints portraits of friends and faculty, including Dr. T. W. MacQuarrie, college president. Is at first interested in teaching art. Member of Sigma Tau sorority.

1931–1932

Scholarship to the Chouinard School of Art, Los Angeles. Studies with Pruett Carter, Morgan Russell, and Lawrence Murphy. Wins Cannon Mills, Inc., national competition ($100 prize) for bath-set design of Trojan horse.

1934

Marries Lee Everett Blair (b. October 1, 1911, Los Angeles) on March 3 at Christ Church, Los Altos, California.

Exhibits in eighth Annual Southern California Art Exhibition, San Diego.

Exhibits with Lee at Philip Isley Gallery, Los Angeles.

Lee and Mary work at Ub Iwerks animation studio, Los Angeles. Continues attending night classes in illustration with Pruett Carter.

1936

Exhibits watercolors at Texas Centennial-Dallas Museum of Fine Art.

1938

Six-week painting trip in Mexico by auto with Lee.

Exhibits at Tone Price Gallery, Los Angeles, "An Exhibition of the Work of Mary Blair," April 7–29.

Elected an exhibiting member of Foundation of Western Art in recognition of her "ability as an artist and her services to Western Art."

1938–40

Employed as "color director" at Harman & Ising/MGM animation studio.

1939

"Practical Values of Art" article in *The Western Woman* magazine, vol. X, #9.

1940

Hired by Walt Disney Studio April 11. Works on *Penelope; Lady; Baby Ballet* (for new version of *Fantasia*); *Dumbo*.

March issue of *The Architectural Forum* article on Blair's house designed by Harwell Hamilton Harris.

1941

Resigns from Disney June 13.

Rehired August 11. Mary and Lee Blair are among eighteen handpicked artists to travel to South America with Walt and Mrs. Disney on three months' goodwill/film research tour for CIAA and President Roosevelt's "Good Neighbor" policy.

1942

Travels to Mexico for Disney film research.

Visits Lee, now a navy lieutenant, at Photo Science Lab in Anacostia, Washington, D.C. Couple live in Galesville, Maryland; Mary travels back and forth to Disney Studio for assignments and meetings.

1943

Saludos Amigos opens February 6; Mary Blair named an art supervisor.

Travels to Cuba for Disney research March 19–April 15.

Creates mural for the Hollywood Canteen and directs the execution of a mural for St. Joseph's Hospital, Burbank, maternity ward.

San Jose State College art exhibits Mary Blair's South American artwork.

1944

Travels to Atlanta and other Georgia locations for *Song of the South* research.

Designs party for *The Three Caballeros* at Oakmont Country Club.

1945

The Three Caballeros opens February 6; Mary Blair an art supervisor.

Works on *Once Upon a Wintertime* for *Melody Time*, and *Little People*, Irish feature.

Paints murals of Baia scenes for Carmen Miranda's living room.

1946

Moves with Lee to New York City; continues train and plane trips to Disney Studio in Los Angeles for assignments and meetings.

In February, Lee forms Film Graphics, Inc. (later TV Graphics), with Bernie Rubin and Leon Levy. October *House Beautiful* magazine article on Blair's L.A. home.

Make Mine Music opens August 15 with Mary Blair as an art supervisor.

Song of the South opens October 12; Mary Blair credited with background & color, also conceptualized live-action sets and costumes.

1947

Donovan Valliant Blair born February 12; family lives at 9 East 61 Street, off Fifth Avenue, in Manhattan.

Mary returns in June to L.A. to work at Disney. "Commutes" periodically between L.A. and New York City.

1948

Melody Time opens May 27, with color and styling by Mary Blair and others.

TV Graphics moves to 250 West 54th Street in Manhattan.

1949

So Dear to My Heart opens January 19. Mary Blair credited with cartoon art treatment; and conceptual sketches for live-action sets and costumes.

The Adventures of Ichabod and Mr. Toad opens October 5, with color and styling by Mary Blair and others.

1950

Cinderella opens February 15, with Mary Blair on color styling.

Illustrates *Baby's House*, a Golden Book; reviewed in *New York Times* February 12, 1950.

Kevin Lee Blair born August 15.

Moves with family to house in Great Neck, Long Island, at 7 Summer Avenue.

1951

Alice in Wonderland opens July 28, with Mary Blair on color styling.

Illustrates *I Can Fly* (a Golden Book).

Buys three acres and built house designed by Frank Nemeny at 110 Beach Road in Great Neck.

1952

Designs shorts *Susie: The Little Blue Coupe* (released June 6) and *The Little House* (August 8).

1953

Resigns from Disney February 1.

Peter Pan opens February 5. Mary Blair does color and styling.

Designs *The Golden Book of Little Verses* (Simon and Schuster).

Ca. 1953–1963

Designs and illustrates national advertisement campaigns for Meadow Gold Dairies, Baker's Instant Cocoa, Blue Bell children's clothing, Nabisco, Johnson & Johnson, Pepsodent, Maxwell House Coffee, Beatrice Foods, and Pall Mall cigarettes, among other products.

Designs Christmas and Easter sets for Radio City Music Hall.

1954

John D. Robinson, Mary's father, dies.

1955

Designs sets and costumes for *Cole Black and the Seven Dwarfs*, an unproduced Duke Ellington Broadway musical.

Designs *The New Golden Song Book* (Golden Press).

1958

Appears in *American Artist* magazine article, pp. 21–25.

1963

Begins work on It's A Small World.

1964

New York's World's Fair opens April 22 in Flushing Meadows, N.Y., with It's A Small World—a Salute to UNICEF attraction at the Pepsi-Cola exhibit designed by Mary Blair.

"About People—Designer," August 2 *New York Herald Tribune* article on Mary Blair and Small World.

1965

Appears on "The Disneyland Tenth Anniversary Show" broadcast on January 3.

1966

Jules Stein Eye Institute opens November 3 at UCLA Center for Health Sciences, Blair-designed large ceramic mural for the children's wing of clinic.

1967

Creates Tomorrowland: "Adventure Through Inner Space" mural art opened February 6 ("The Spirit of Energy Among Children").

Serves as color designer for film version of *How to Succeed in Business Without Really Trying*.

1969

Designs Parkwood wading pool (opened May 29) in Great Neck, Long Island.

1970

Lee and Mary sell Great Neck property and move to Soquel, Caifornia.

"Three Dimensions" art exhibit and sale is held September 18–19 by three Disney artists (Mary Blair, Al Dempster, Blaine Gibson) for third annual Disney Artists for Cal Arts invitational benefit.

1971

Designs ninety-foot mural on Walt Disney World Contemporary resort hotel at Walt Disney World (completed in June).

1974

Appearance by San Francisco Symphony Orchestra, Seiji Ozawa conducting Ravel's *L'Enfant et les Sortilèges* December 11-20 and illustrating slides by the Blairs.

1977

Slips in shower; suffers blood clot in leg.

1978

Dies of cerebral hemorrhage July 26 in Dominican Hospital, Santa Cruz.

Services held July 29 at St. John the Baptist Episcopal Church, Capitola, California.

1980

Gussie, Mary's twin, dies. Margaret, Mary's sister, dies.

Varda, Mary's mother, dies.

1991

Awarded a posthumous Disney Legend Award October 22.

1995

Honored by Women in Animation, Hollywood chapter February 22.

Lee Blair dies April 19.

1996

Posthumous Winsor McCay Award by ASIFA-Hollywood November 10.

2003

Posthumously given National Fantasy Fan Club's Disney Legend award January 18.

Index

Acknowledgments

This book would not have been possible without the full cooperation of Mary Blair's loving family, including Kevin Blair, Donovan Blair, Maggie Richardson, and Jeanne Chamberlain; among many kindnesses, they provided me with superb examples of original art, candid interviews, and encouragement.

Equally responsible for making this book a reality are a dedicated group of Mary Blair admirers who have long sought a showcase for her extraordinary art and life; they include Pete Docter and Jonas Rivera from the Pixar studio; Mike Giaimo; Ken Shue, Tim Lewis, and Brent Ford of Disney Publishing Worldwide; and Lella Smith, Tamara Khalaf, Jackie Vasquez, Fox Carney, and Vivian Procopio of the Walt Disney Animation Research Library (ARL). I am deeply grateful to them for all the time and trouble they took in locating, collecting, and reproducing artwork from the ARL's vast collection of original Disney art and private collections, and for all the advice, enthusiasm, and support they have so generously provided me.

I am indebted to Michael Johnson who located and photographed several early Mary Blair watercolors from his own collection, as well as the Mark and Jan Hilbert Collection, and the Craig & Gigi Barto Collection.

For additional artworks of the artist, I am grateful for the generosity of several collectors, including Mike Glad and the Glad Family Trust; Roger Allers; Sue and Eric Goldberg; Alice and Marc Davis; Dug Miller; Mike Gabriel; Fred Cline; Howard and Paula Lowery; Jordan Reichek; Robert Zymet; and Kathryn Beaumont.

My research was greatly facilitated by David R. Smith, Robert Tieman, and Becky Cline of the Walt Disney Archives; Mike Jusko and Hugh Chitwood at the archives of Walt Disney Imagineering; and Ed Squair of the Disney Photo Library.

Several of Mary Blair's professional associates and friends gladly spoke of their work with her, including Frank Thomas, Ollie Johnston, Rolly Crump, Alice Davis, Joe Grant, John Hench, Martin A. Sklar, and Neil A. Grauer.

A number of distinguished historians, writers, and critics generously shared their thoughts and documents on Mary Blair's art, including Karal Ann Marling, professor of Art History and American Studies at the University of Minnesota; Robert Perine, cofounder of the Chouinard Foundation; Charles Solomon; Howard Green; Michael Barrier; Zimra Panitz of the Whitney Museum of American Art Library; Ross Care; William Moritz; and Robin Allan.

Others whose kindnesses should not go unacknowledged are Diane Disney Miller, Roy E. Disney, Sheila Saxby, Sue Arena, Sue Perrotto, Jonathan Annand, Byron Howard, Jeff Kurtti, John Franceschina, David Hajdu, Will Friedwald, John McIntyre, Jennae Champeau, Jim Korkis, Les V. Perkins, Bob Staake, John Franceschina, Mark Mitchell, Rich Taylor of Gifted Images, Eugene Salandra, Tony Anselmo, and Andreas Deja.

My agent Robert Cornfield continues to be a trusted guide and friend. A champion of this book from the start, Wendy Lefkon is the very model of what an editor should be—encouraging, supportive, positive, organized— a solid pro who is always there for me and always great fun to be around.

Thank you to my husband, Joseph J. Kennedy, for once again being there and for being Joe.

About the Author

Photo: Joe Henson

JOHN CANEMAKER *is an Academy Award– and Emmy Award– winning independent animator, animation historian, teacher, and author.*

He won a 2005 Oscar and a 2006 Emmy Award for his twenty-eight minute animated short "The Moon and the Son: An Imagined Conversation." He also created animation for the Oscar-winning documentary *You Don't Have to Die* (HBO); the Peabody Award-winning *Break the Silence: Kids Against Child Abuse* (CBS); the Turner Classic Movies documentary *Chuck Jones: Memories of Childhood*; and a sequence in the Warner Bros. feature *The World According to Garp*, among other films.

Forty years of his personal and sponsored films and production artwork are housed in the permanent collection of New York's Museum of Modern Art (MoMA). In 2008 MoMA featured Canemaker's 1998 short film "Bridgehampton" in its Jazz Score exhibit, with continuous screenings and original animation art from the film on exhibit. Milestone Film & Video distributes a compilation of short films "John Canemaker: Marching to a Different Toon" and "The Moon and the Son: An Imagined Conversation."

John Canemaker is a tenured professor at New York University's (NYU's) Tisch School of the Arts/ Kanbar Institute of Film and Television where, since 1988, he has headed the animation program. In 2009 he received NYU's Distinguished Teaching Award for Exceptional Teaching, Inside and Outside the Classroom. The John Canemaker Animation Collection, part of the Fales Collection in NYU's Bobst Library, is an archival resource that was opened to scholars and students in 1989.

One of America's most respected animation historians, Canemaker is the author of ten acclaimed books on animation history covering subjects ranging from Winsor McCay and Felix the Cat to Tex Avery and Disney's Nine Old Men that are among the most important and thoroughly researched in the field. He has contributed more than one hundred related essays, reviews, and articles to a variety of periodicals, including *The New York Times*, the *Los Angeles Times*, and *The Wall Street Journal*.

His international recognitions include a special Animation Theory Award from the 2006 Zagreb Animation Festival and Italy's Le Giornate del Cinema Muto's Jean Mitry Award. ASIFA-Hollywood honored him as well with the prestigious Winsor McCay Award in 2007 for Distinguished Lifetime Contributions to the Art of Animation. Canemaker was granted an honorary Doctor of Fine Arts degree from Marymount Manhattan College in 2007 and received two residency grants (in 1999 and 2009) from the Rockefeller Foundation's Bellagio Study Center in Italy. He was the first National Film School Visiting Fellow (2009) at Ireland's Dun Laoghaire Institute of Art Design and Technology.

For more information, visit johncanemaker.com